DRAGONHENGE

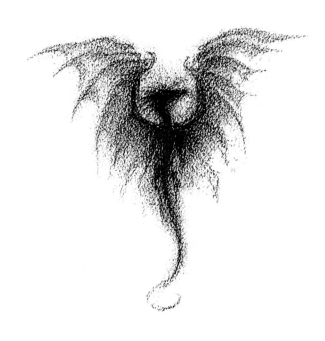

DRAGONHENGE

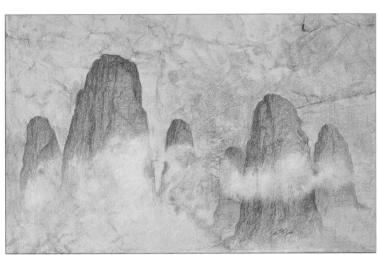

BOB EGGLETON · JOHN GRANT

Paper Tiger

Notes on the Genesis of this Book

When I conceived the word 'Dragonhenge', little did I foresee it would take on a life of its own. What you hold in your hands is the result of several years of thinking and of bouncing ideas back and forth. I wanted to explore new media and new techniques – I believe the true goal of any piece of artwork is exploration. Initially I did a few pictures which John used as a springboard to go off in his own direction. Thereafter, he sent me sections of the text which I used as a springboard to go off in *my* own direction. I wasn't out to 'illustrate' things word for word. Moreover, I would often let my dreams and subconscious take me in further new directions. The pictures may spawn other story ideas entirely, while the text may conjure up other pictures in your own mind. This book has been like an interactive dream for both of us. I hope you view it similarly.

– Bob Eggleton, April 2002

This book went through several transformations during discussions between Bob and myself before the first word was written; one of our notions, for example, was to take a quasi-archaeological approach, relating the discovery by humans of the edifice called Dragonhenge and the deductions made therefrom about the ancient dragon civilization that had built it. But eventually I became unhappy about humans playing a part in the tale at all; this should be the dragons' book, not ours. I therefore set about creating the elements of the dragons' own oral mythology. I soon found that, in order to tell these tales, I had to enter the mindset of the dragons, forgetting my own humanness as much as possible and deviating quite a lot from the customary in my use of the English language. There then began a frenzy of richly rewarding – and extremely exhausting! – interactive creativity, with each of us endlessly inspiring the other to take new artistic risks. I hope you agree those risks were worth taking.

– John Grant, April 2002

First published in Great Britain in 2002 by
Paper Tiger
The Chrysalis Building
Bramley Road
London W10 6SP

An imprint of Chrysalis Books Group plc

9 8 7 6 5 4 3

British Library Cataloguing-in-Publication Data: A catalogue record for this book is available from the British Library

ISBN: 1-85585-972-6

Designed by Malcolm Couch

Colour reproduction by Bright Arts Pte Ltd, Singapore
Printed in Singapore by Kyodo Ptg Singapore Pte Ltd

CONTENTS

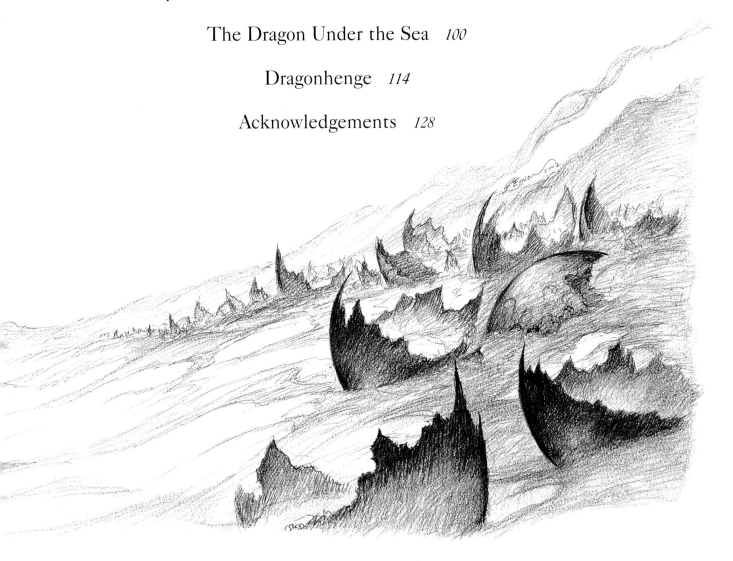

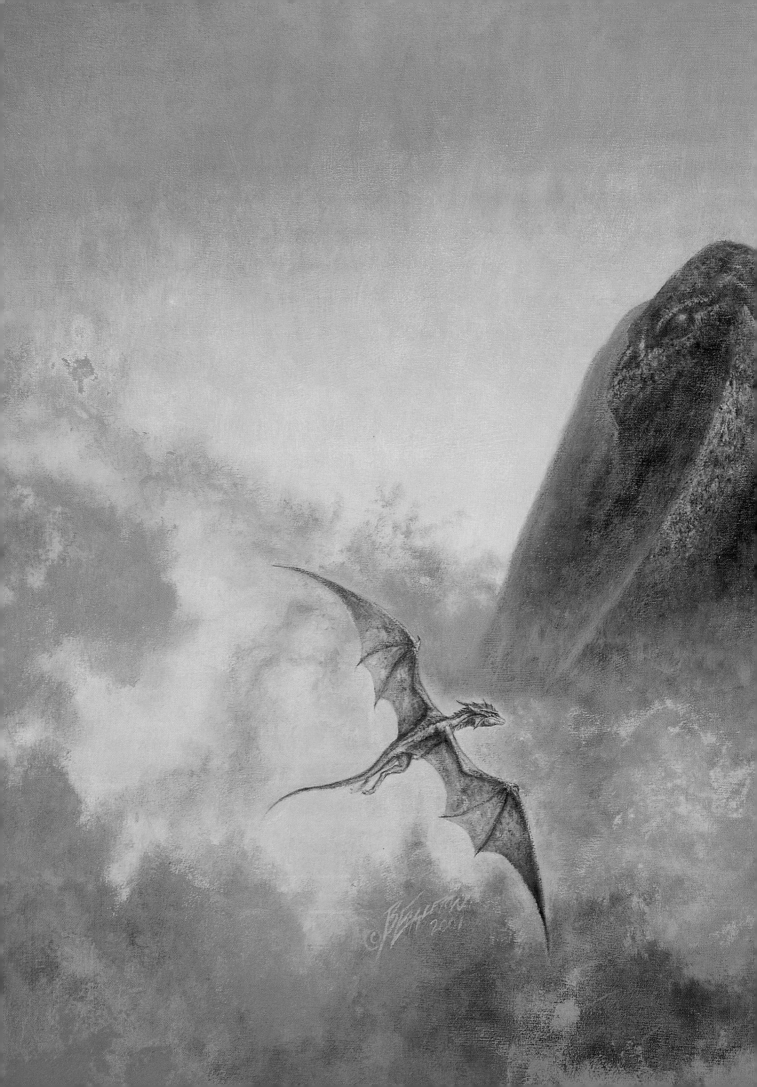

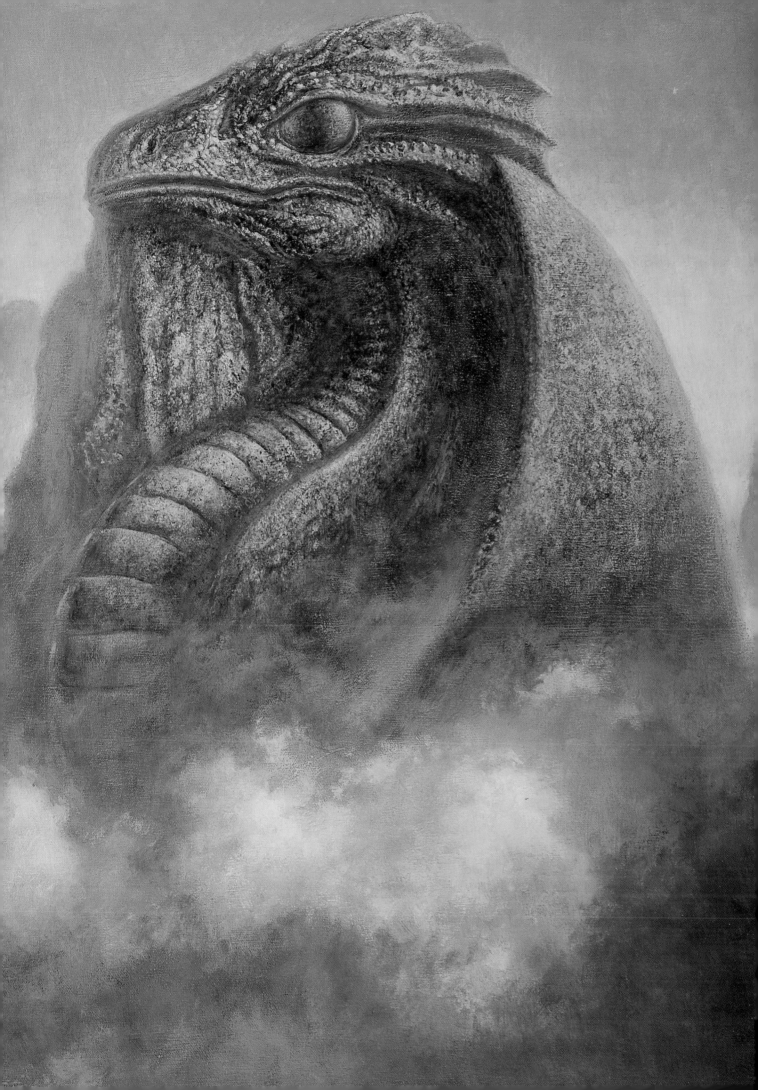

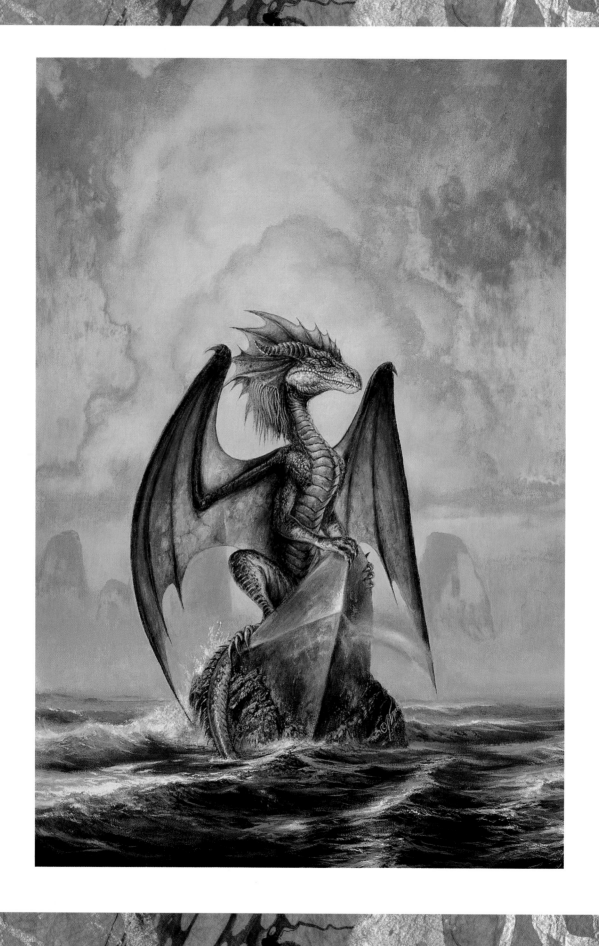

PROEM

I am the last of my kind.

I have flown the winds of the World, seeking companions, but all I have encountered have been the humble creatures, the ones that inherited the land and ocean and clouds from us. There are no true speakers left, no people, except myself, and thus my recollection fades of all that I once knew. I fly through mists not just of the World but of my memory.

I have seen the rotting wrecks of what my kind built. They are hunted among by the humble creatures, who know them, if their unformed minds are capable of knowing them at all, as merely rockfalls. They do not see the marks where talons wrought; the humble creatures cannot be brushed by the minds that made these things.

Yet once, I cannot recall how long ago, I was drifting with the clouds when I came across an island of ragged stone and high cliffs, buffeted by hungry waves. Upon that island soared eight mighty towers that were hushed with their own ancientness.

I flew among them and wondered. No humble creatures came here to this island, not even the feathered ones, the false dragons. I felt as if I had come upon a huge cavern that had long been deserted by those who had dwelt there, but that nonetheless they had waited to welcome me to a home I had never seen.

I alighted at last upon one of the towers, whence I could look down upon the landscapes of the clouds, and watch how they reconstructed for scant moments the glories that once our kind had built.

And then the stone tower spoke to me, telling me a tale – a tale of how things had begun with the breath of the Great One for whom I was named.

It told me this tale, and then I flew beneath the watchful eye of the sky
to the next tower, where again I was told a tale.

Each of the towers had a tale to tell, and each of the towers did I perch
upon, until all were done. Then I flew away to a far eyrie to reflect upon
what I had learned, to roam within the eight tales until I knew them, their
people and their vistas, and was a part of them and they a part for all my
life of me. I became the holder of those tales: my wings and bones and flesh
and claws were their eggshell.

I flew back, then, to the island – to my home.

But the waves were naked where it had been. I cast wide and far, wide
and far as there ever was or ever could be, but nothing of the island or its
towers could I see.

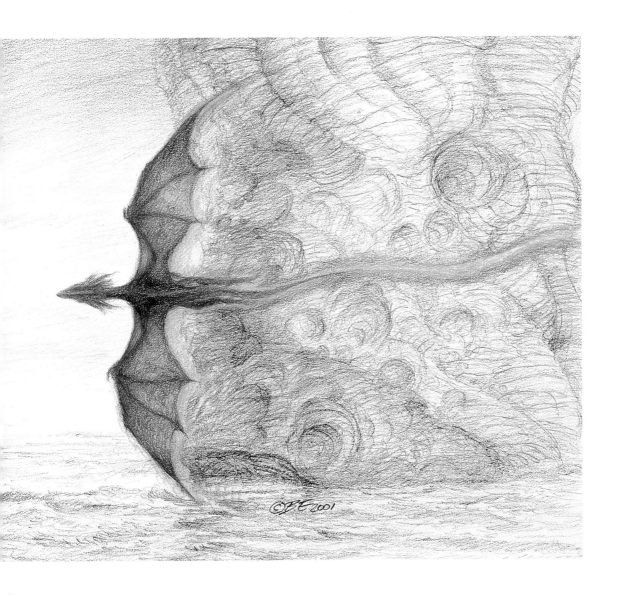

And then it came to me that the place I had visited and its towers
had been built not of stone but of memories, and that this was why I could no
longer find them, for the memories had been swirled away by the winds, scat-
tered among the clouds and the seas like smoke made invisible.

 One day they will become whole again, if only fleetingly, somewhere
in the World, and until that day I will fly the skies in search of them, just as
the Memory of the one for whom I am named seeks forever, as the towers
told me, the part of him that fled.

 The towers were built of memories, and memories are thin and fragile
things, easily dispersed.

 As am I, for since that day I have been a creature formed from
memories, not flesh.

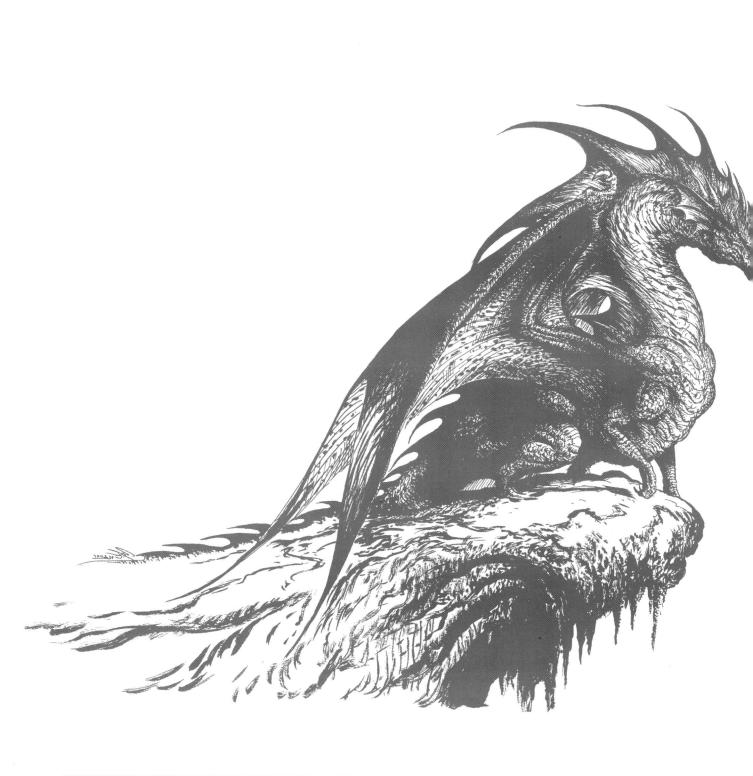

THE DREAM OF QINMEARTHA

IN THE BEGINNING there was nothing in the Void except the First Dragon, who was called Qinmeartha and had no substance, but who possessed the Principles of Water, Fire, Earth and Air, and *was* those Principles.

It occurred to Qinmeartha to fill the Void, and so he breathed upon it, making real the Principle of Water that he possessed and was. But that first breath of his was without Fire, and all that it made was a river of cold steam across the sky that can still be seen.

To his next breath he added the Principle of Fire that he possessed and was, and the Fire condensed out of the river of his breath to make droplets that were the suns.

For his third breath he drew also upon the Principle of Earth that he possessed and was. With this breath he created the World, and all the worlds that there are. He created the land and the seas and the Mountains-That-Roar.

For his fourth and final breath he called upon the Principles of Water, Fire and Earth once more, but also now upon the Principle of Air that he possessed and was, and with this breath he created all that moves and is alive. And it was with this breath that he poured the last of the entirety of himself into the Void, so that there was nothing left of him, and Qinmeartha was no more except that he had become everything: he had become the suns and the worlds and all that was upon those worlds.

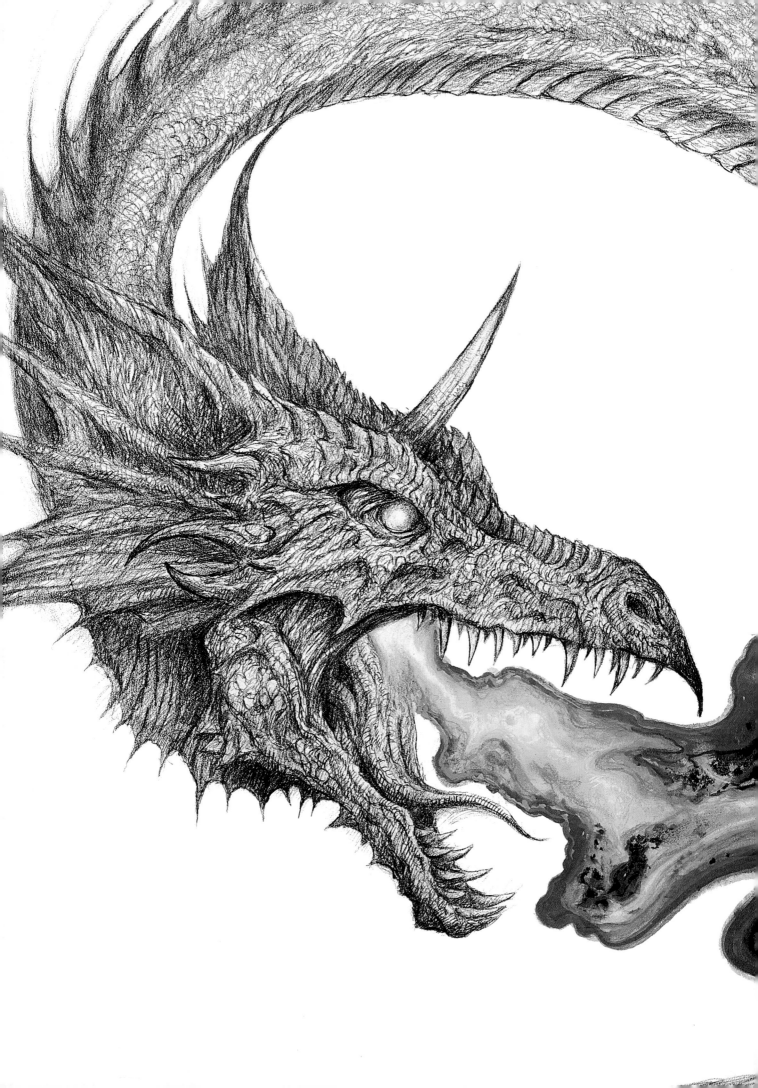

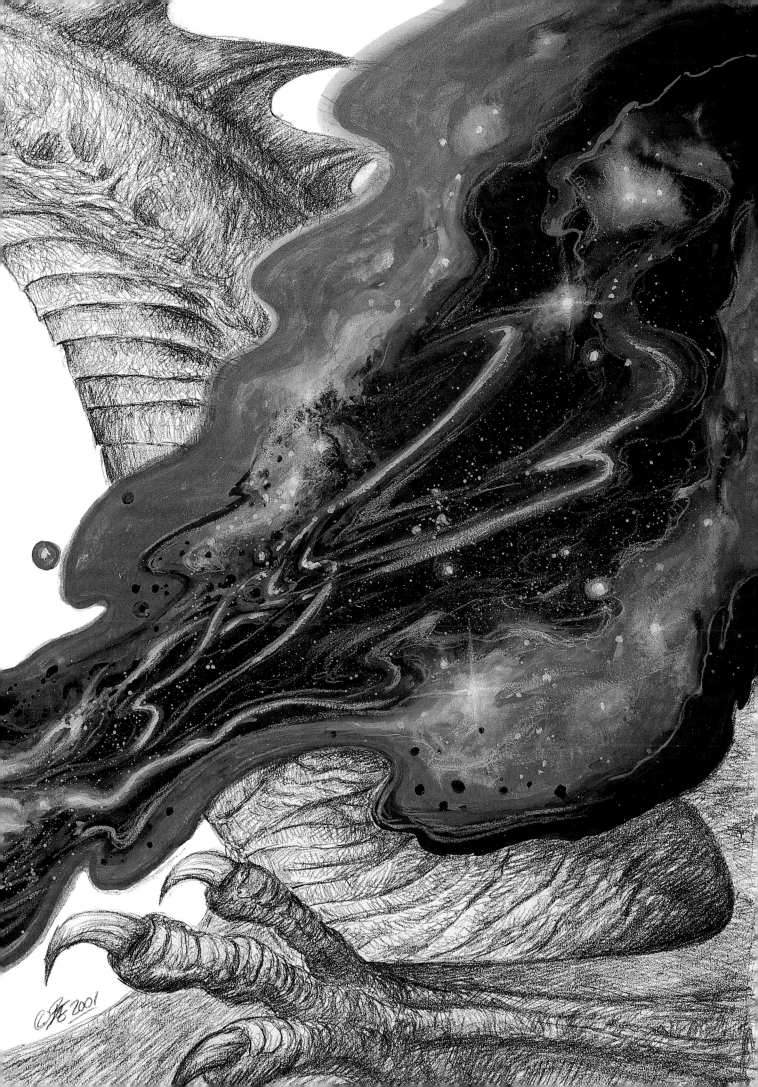

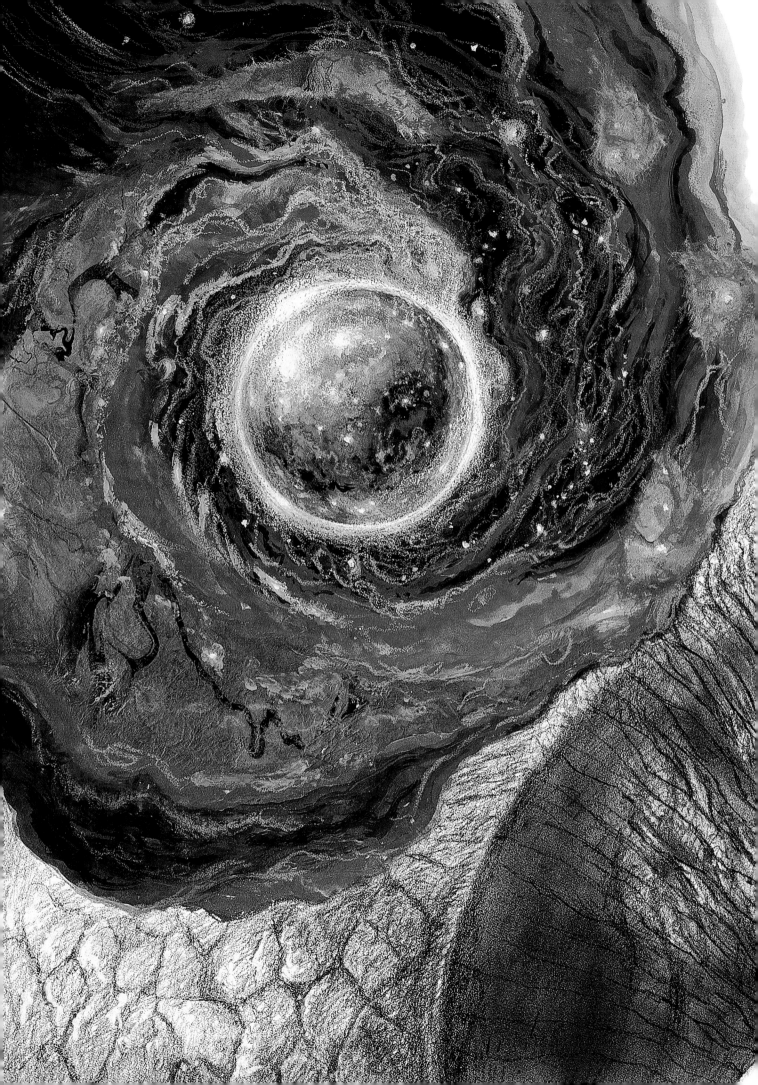

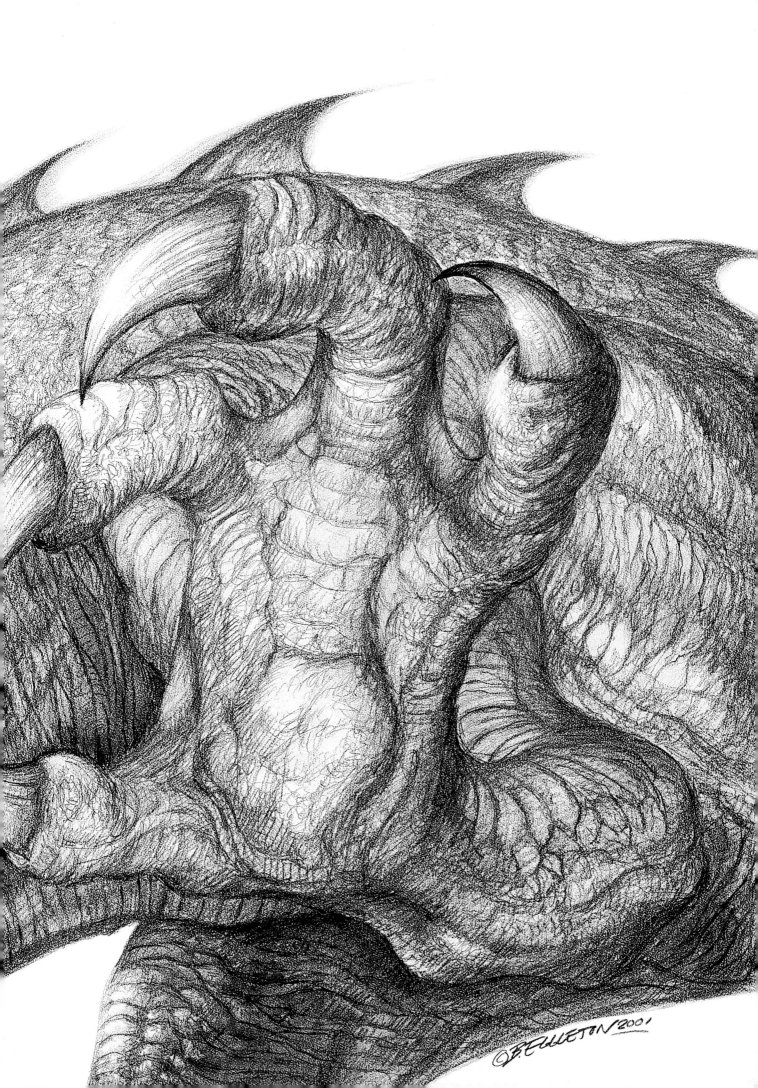

In the moments of his dying, Qinmeartha had a Dream, and this Dream was of others like himself.

When he was dead, the Dream still lived. And the Dream embraced the worlds that now filled the Void, and where those worlds recognized the Dream they gathered it to themselves; and the Dream became the dragons, who, like Qinmeartha, the First Dragon that there ever was and ever could be, embody within themselves the Principles that are Water, for we have blood; and Fire, for like Fire we are more than the material of which we are made; and Earth, for like Earth we have substance; and Air, for Air is the lover that is our soul.

This is why we dragons are also called the Dream of Qinmeartha. We are *of* the Dream; we *are* the Dream; in everything we do we give birth to the Dream anew.

And through the dragons and the worlds and the suns and the river that were his first and last four breaths the dead dragon Qinmeartha lives eternally.

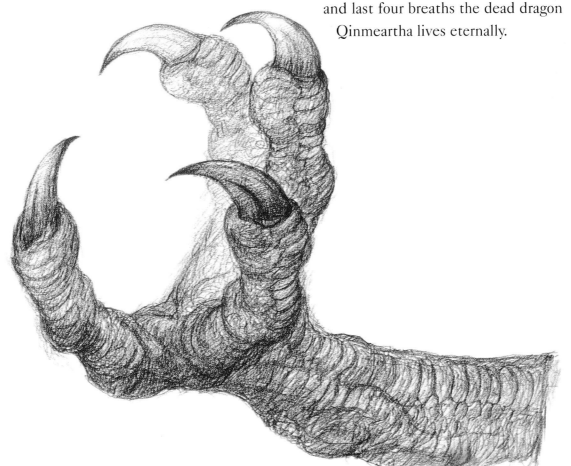

THE WINGS OF SYOR

ALTHOUGH QINMEARTHA had dreamed all that
there is, his Dream was not entire. There were
things still to make and do, which was why
he had brought us into being: so that his Dream could
be eternally redreamed.

The World was filled with Light in those earliest
days, but it was a grey light, even though the skies bore
garments of every hue and the many suns of the night
gazed upon the World through eyes of every colour –
even though the Sun itself stared yellow from above.

Many of us lived and many died, and none thought
to ask why this was so as they crafted the shape of the
World and its uncountable islands. For the people of
those times were larger than mountains and longer than
rivers, and the ashen fire of their breath could shroud
the seas. Their footsteps became lakes, their talons
scraped out gorges, and their wrath became the
Mountains-That-Roar. With their wings they raised
hurricanes that scoured the earth into the sea, where
it became hills of mud that they moulded and sculpted
and then baked with their breath to be the clay of
new lands.

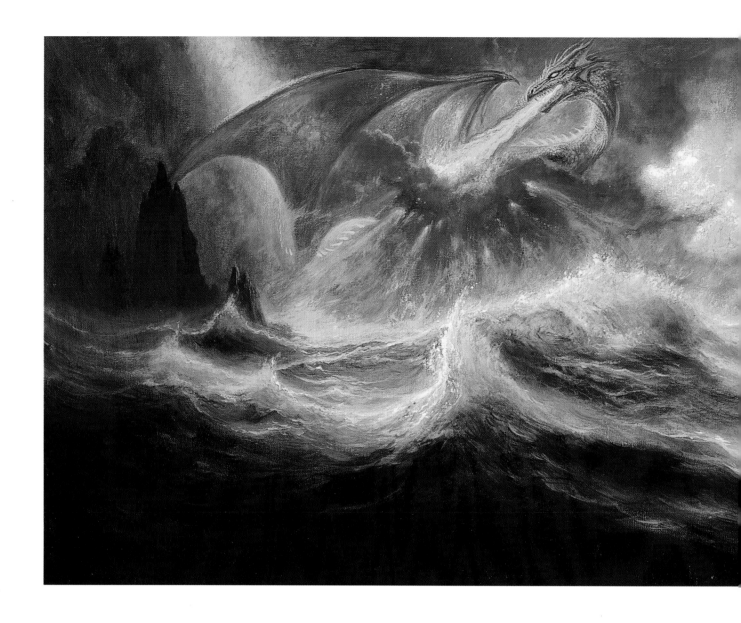

All around the World they flew, to the hot places where the Sun was directly above them, though few would stay there long, and to the cold places where it slunk close to the land, though few would stay there long. High, high they flew, to where the air was thin and cold, though few would stay there long. For sustenance they had fire that was *the* Fire, earth that was *the* Earth, water that was *the* Water, and air that was *the* Air. They were the great ones of our past, greater than we shall ever know, for they were the first inheritors of Qinmeartha's Dream.

Yet for them all the World was grey.

The eldest and the greatest ones of them looked upon this greyness and decreed that it was good, but the Lessers among them – for there were Greaters and Lessers in those earliest times – gazed up

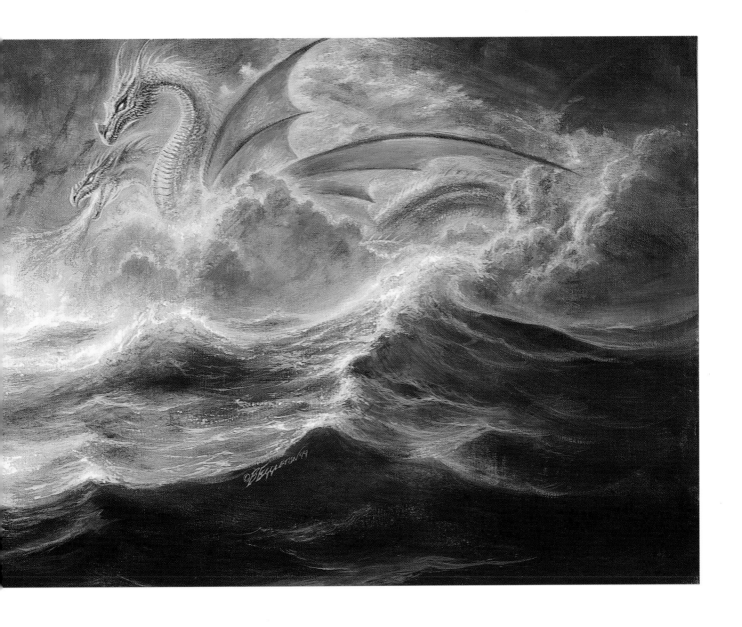

at the gaudy shouting skies and asked if Qinmeartha's Dream had indeed been truly realized in the World. But such questions were stifled by their Greaters, who reasoned: If Qinmeartha had wished his Dream otherwise, would not he himself have made it so? While the Lessers, though only among themselves, reasoned that, if their task was eternally to redream the Dream by shaping the World, then surely it was no evil to think of other shapings than the mere moving of mountains and building of islands.

Generations went by, and the Sun began the dimming whose end will mark the end of eternity. Other creatures, the humble creatures, were brought into the World, and grasses and trees were permitted to spread across the lands. And with them came a thinning of the Fire and the Earth and the Water and the Air that were us and sustained us, so

that at last Greaters and Lessers alike had to feed upon the humble creatures. Disputes arose among those dragons of our ancient past, and factions that later became the clans that we now are. It seemed as if the Dream of Qinmeartha was turning to sour blood.

And still all the world was grey.

There was a Lesser called Syor, also called She Who Seeks to the Ends of Roads – she was not the first to bear that larger name, which truly belongs to the Girl-Child LoChi – and she had not yet borne eggs. Basking once upon the cliffy shore of an island made so long ago that its name had been forgotten, she looked for a thousand thousandth time at the yellow of the Sun and the striving blue and white of the cloud-scuffed sky above and wondered why it was that the World held none of these living hues, for all that it was alive. Even those colours that she saw had no names for her, for none had seen need

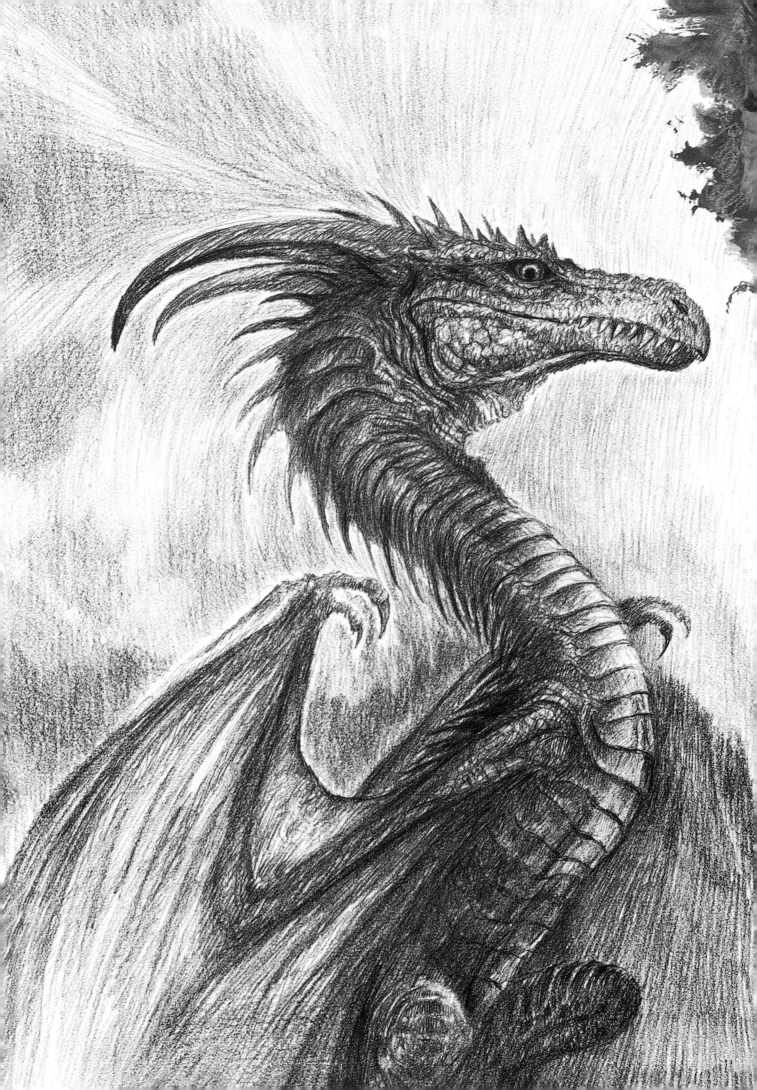

to give names to what the World did not have. And as she stared directly into the yellow eye of the Sun, seeing its fire – the Fire that it shares with all of us – she suddenly felt as if all its colour was flowing into her through her eyes and then coursing through all the veins of her body.

There she stayed watching the Sun every day for more years than any of us now may live, and when at last she turned away she saw not a grey sea and a grey land and grey mountains, but all the colours that there are and ever could be. She breathed fire in a great beacon ahead of her and it contained red and yellow and blue and orange and white. And she believed, falsely, that during her long whimsy of sky-watching the Greaters had at last permitted colour to enter the World, so fulfilling further the Dream of Qinmeartha.

And so back to her roost she flew, eyes and breath alight with joy.

But she was not met with joy, for, even as all that she could see was coloured, all that her roost-mates could see that was coloured was Syor herself, She Who Seeks to the Ends of Roads. She was the only coloured thing anywhere in the World, her breath a fountain of liquid fiery brilliance, her scales a shimmer of the Sun and the Moon and the starry lights, and her wings, as she extended them in her joy – oh, her wings were the finest thing there ever was seen, for her wings were all the colours there are and ever could be.

Yet the Greaters of her roost growled and spat at her in their wrath at what she had done. Up they circled and around her, driving her too ever upward, casting their own flames upon her, until her magnificent scales began to shrivel away, and her eyes sizzled in their sockets, and her talons began to glow of their own heat. Higher and higher she spiralled, hoping hopelessly to escape their tornado of fire, screaming her agony, until at the last in her anguish she stretched her wonderful wings as far as they were able, so that they arched the whole sky.

And as she died and her wings became ash, all the colours of the Sun flowed back out of her, and those colours spread faster than thought into every corner of the World, so that trees were green, and mountains were purple, and rivers were brown, and rocks were grey and red. Of everything in the World, flowers and fire were those which took the most colours, and so today still both are often called the Daughters of Syor, though most especially the flowers.

There have been others called She Who Seeks to the Ends of

Roads, but Syor was the first of them in the World and the only one save the Girl-Child LoChi who became also She Who *Leads* to the Ends of Roads, for she brought us the colours of the World, which are the colours that *are* the World. And she sometimes shows herself to us even now, spreading the pale veils of her wings in an arch across the sky.

JOLI'S FLIGHT BEYOND THE STARS

IN THE GENERATIONS that came after Syor there was a dragon who was neither a Greater nor a Lesser and he was called Joli. He was known almost throughout the World wherever there were tongues to talk and breaths to flare for the foulness of his disposition. He lived alone on a waste and rocky island he had built himself, and there he guarded Secrets that to this day no one of us has ever been able to learn. Yet it is said that whenever wayfarers alighted on his island by chance, through exhaustion of the flight or through hunger, he would be kind enough to them, although eager that they should leave again soon.

What no one knew but what we now know is that on his waste and rocky island he was hoarding not just Secrets but bright colours he had discovered locked into crystals he had found among the rocks. Others would have coveted

those colours had they known about them, but all assumed his Secrets were not worth the discovering and left him well alone.

Joli did not fly often and he did not fly well, for in flight, he believed, there could be no Secrets. No, most of his days he spent squatting at home on his waste and rocky island. But, some days, he did take to his wings, for who knows what purpose, and he could be seen from afar wallowing uneasily through the air, his ungainly body lurching

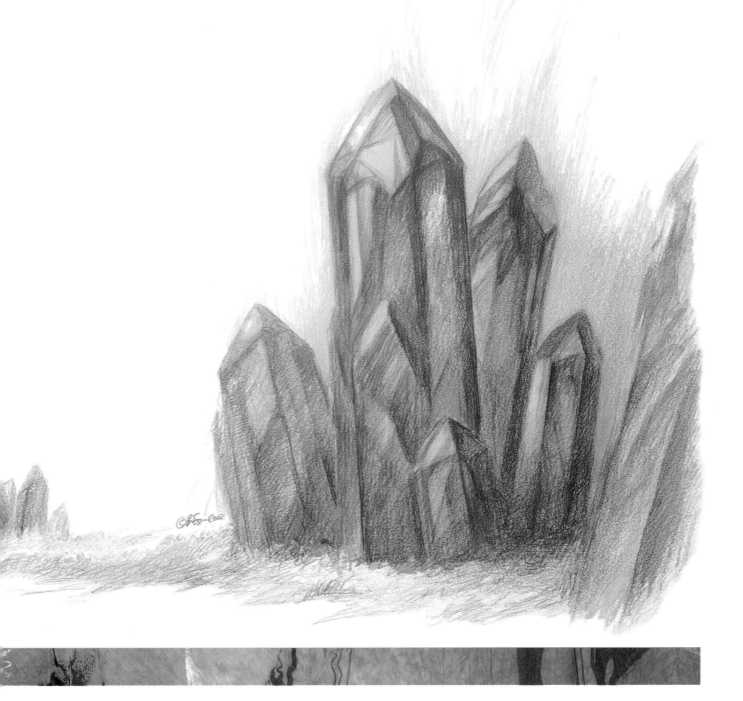

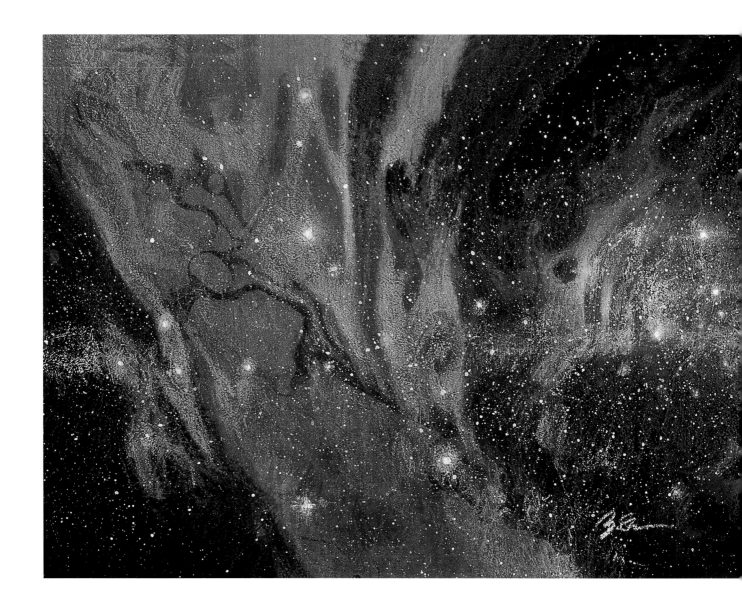

beneath wings that seemed too small. And on one of these days, his
mind possibly astray along the road towards another Secret, he flew
close by the upper flanks of a Mountain-That-Roars and was caught
by a ferocious upwind.

Even though his wings were so small, his body was broad, and the
upwind bore him looping towards the skies. Some younglings saw this
and they told their elders, but all were too far from him even to hear
his cries. Upward and ever upward he was carried, his wings torn by
the speed of his passing, until he was beyond the clouds. And even
there the cruel upwind did not leave him, for this was no infant
Mountain-That-Roars but one greater than any we can know today.
Joli was taken beyond the clouds and beyond the lands that lie beyond
the clouds, and then he was taken beyond the Moon, in the passing
of which he saw the strange grey dragons who dwell there. And once

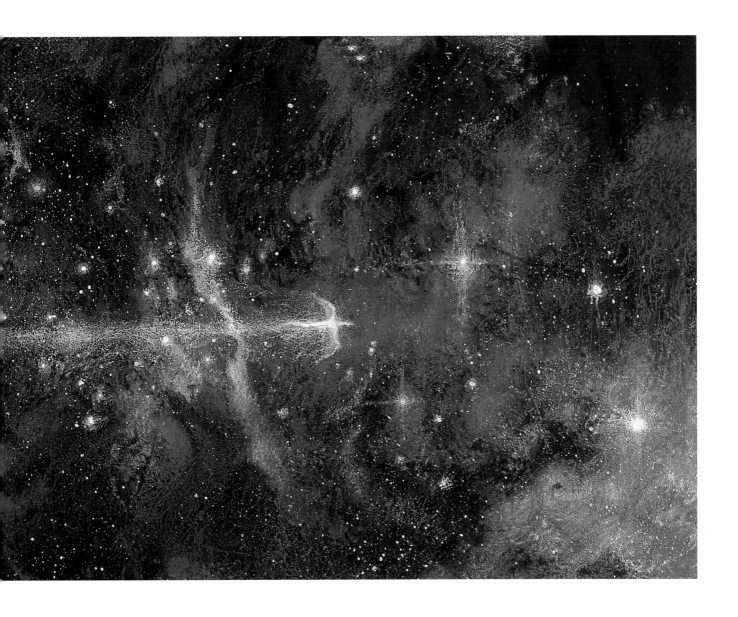

beyond the Moon he was taken beyond the Sun, in the passing of
which he saw the strange golden dragons who dwell there in the
caverns of flame, whose scales are made of liquid fire and whose breath
is the stuff of Qinmeartha's Dream. And even there the cruel upwind
did not let him be, for now it drove him upward and upward beyond
the lands that lie beyond the Sun until he was beyond the land of
the stars, in the passing of which he saw the many strange dragons
who dwell there, some of whom are plumed with Stars-That-Grow-
Crests and whose very eyes are larger and fiercer than the Sun,
others of whom are smaller than the tiniest ember and yet glow
more brightly than any.

Still onward did the cruel upwind drive the poor Joli until even
the lands beyond the stars were far and invisible beneath him, and
he came to a place where he could gaze upon those parts of the Dream

of Qinmeartha that Qinmeartha had *not* Dreamed, the pieces of Dream that the Creator had not known were there within him.

And there at last did the upwind cease to torment the poor Joli, and he found himself becalmed.

There came to him in that empty, lightless place a small dragon called Alyss, formed out of those pieces of the Dream that Qinmeartha had *not* Dreamed. At first in his terror he mistook her because of her size for a Lesser, but as she calmed him he began to see that she was greater than any Greater there ever has been or ever could be, save only the great Qinmeartha himself – and perhaps even greater than he.

'Why have you strayed here?' she said to the poor Joli.

'I have strayed here because I was driven here by an upwind from the mightiest Mountain-That-Roars there ever has been or ever could be,' he replied.

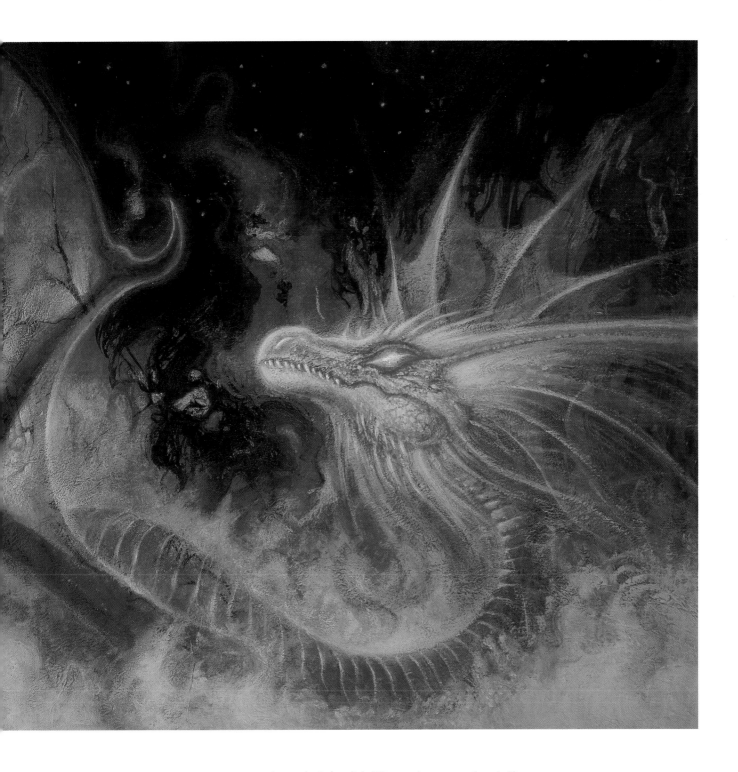

'Then you cannot stay here,' she said. Her voice was the delicate violet of the most exquisite small jet of flame you have ever seen or ever could see.

'I do not wish to stay here,' he said, you may be sure. 'I wish to return to the World, and to my waste and rocky island, and to my Secrets, and to the colours I have discovered locked up in crystals among the rocks of my waste and rocky island.'

'Then to the World I shall return you,' she said. 'But first, for straying here and for my aid in returning you to the World and to your waste and rocky island, you must give me the gift of taking something from me.'

'And what is this thing?' said Joli, thinking, you may be sure, that it is not much of a gift to have to give if you instead take something.

'It is a sword,' said the small but great dragon whose name was and is Alyss and who was created from undreamt bits of the Dream of Qinmeartha.

In those days there were no swords, but Joli had heard of such nevertheless.

'I have no need of a sword,' he said. 'No dragon has need of a sword. We have our talons and our scales and our breath of fire that is also *the* Fire.'

'It is a sword you cannot see,' said the small but great dragon, 'and it is sharper than any metal sword there ever was or ever could be. It is a Knowledge. It is the Knowledge of Life.'

At this Joli fell silent, for all the Greaters and even all the Lessers believed in those days that the Knowledge of Life was not something that it fell within the Dream of Qinmeartha for mortal dragons to

possess. And yet it was perhaps the greatest Secret there ever had
been or ever could be, and so naturally he wished to possess it to add
it to his hoard.

'I will give you this gift,' he said.

'You had no choice,' she said, 'unless you wished to stay here
forever in the land that is beyond even the lands that are beyond the
skies, and never return to the World, and to your waste and rocky
island, and to your Secrets, and to the colours you have discovered
locked up in crystals among the rocks of your waste and rocky island.'

He fell silent again, for the truth of her words was clear.

'Look on this,' she said, and she waved a wing, and as she waved
her wing there fell from it tiny motes of colour in a curtain that became
a river far in the distance below them. And the river was in torrent, its
waters crying out their eagerness so loud that Joli could hear them even
from far up here. And all the waters of the river were charging like
hungry younglings towards a great waterfall, whose noise was louder
than the wrath of any Mountain-That-Roars there ever has been or ever
could be, so that now as Joli gazed upon it he could no longer hear the
eager cries of the river's spating waters behind
it. And at the foot of the waterfall, away from
the tumult, there was a great deep pool,
broader than any pool there ever has been
or ever could be, deeper than any pool
there ever has been or ever could be,
and *stiller* than any pool there ever
has been or ever could be.

'That is the Knowledge of
Life,' said Alyss.

Joli gazed from on high at this
river and this waterfall and this
great still pool and yet he could not
understand what the meaning was
of this Knowledge.

'Life,' said Alyss, 'is the line of
the waters across the very crest of that waterfall. No
droplet of water can remain there for more than an
instant, for that is all that mortal existence is: an
instant. In the time that the waters remain on that

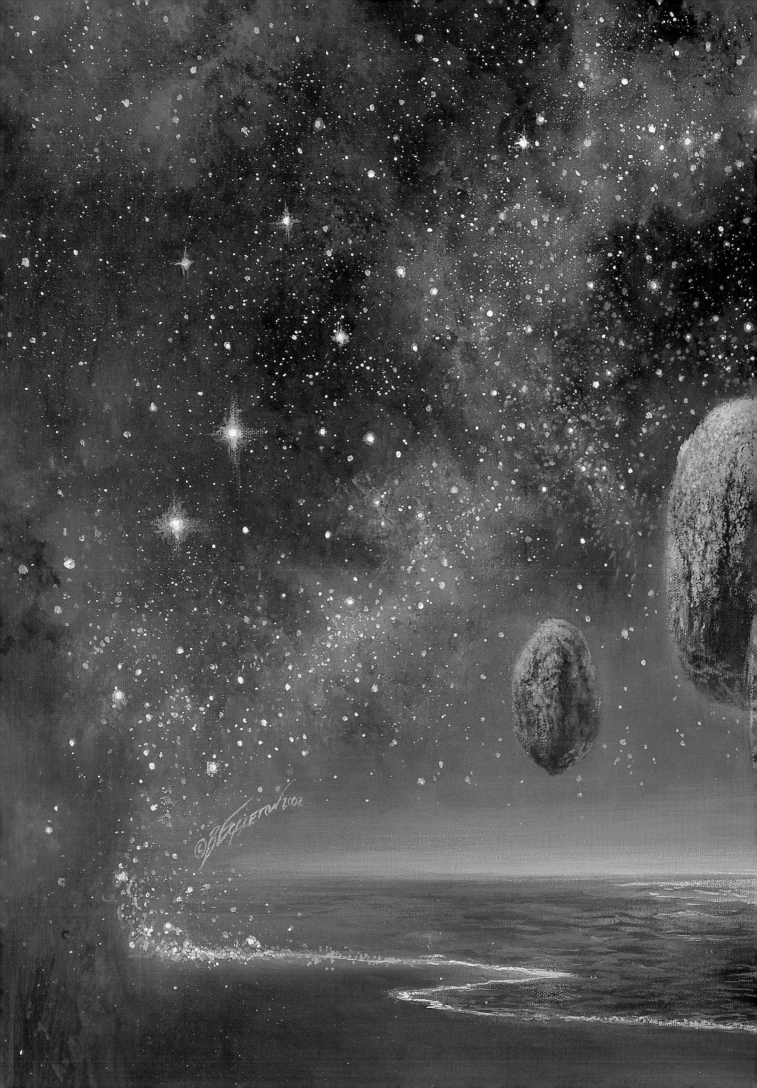

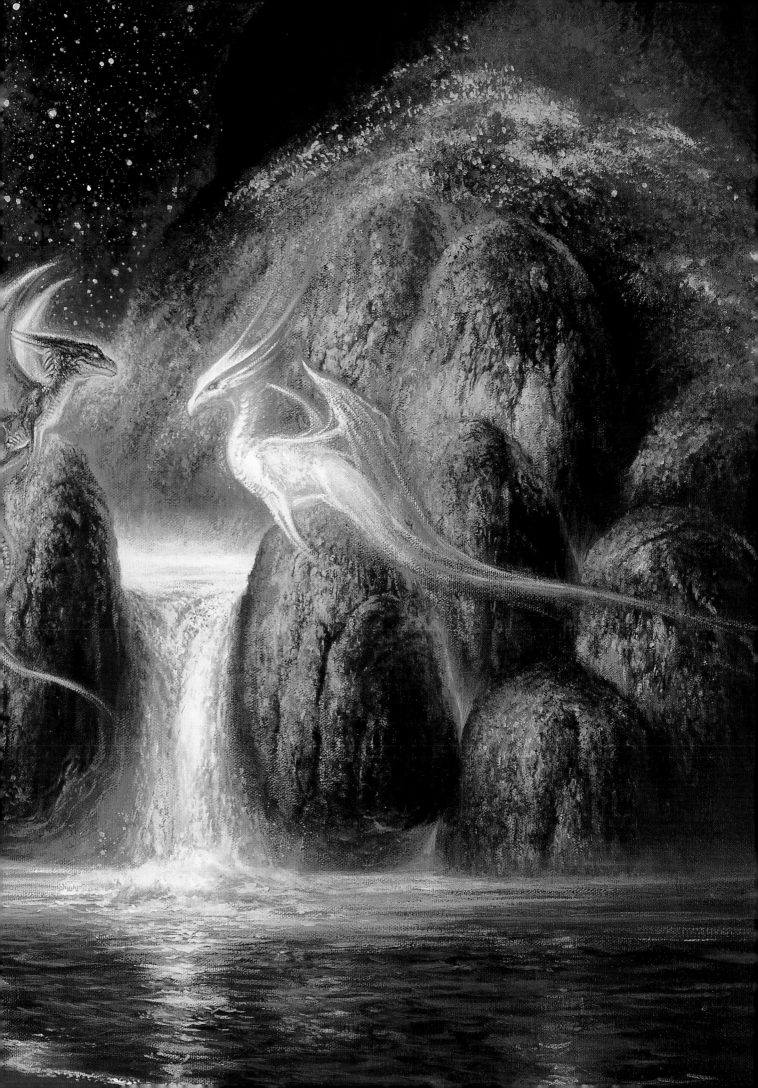

crest you can tell no droplet separate from any other droplet, and afterwards they become all one: all of them, all together, are the great still pool, the pool that is greater and stiller than any other pool there ever has been or ever could be.

'Now see how foolish are the waters of the river, which are also the dragonsouls waiting to be brought into existence, for they clamour eagerly for the instant that they are at the crest of the cataract – for the moment, shorter than the wink of a star in the night sky, when they may move about the World – and yet they dread the foreverness they will spend in the great still pool, the pool that is greater and stiller than any other pool there ever has been or ever could be.'

'And yet are the waters of the river not also wise as well as foolish to clamour so eagerly?' said Joli. 'For that one instant at the crest of the cascade is worth all the foreverness thereafter in the pool.'

Then did the small dragon who was greater than any Greater look at him sternly.

'Their folly,' she said, 'is in dreading the foreverness in the great still pool, that is greater and stiller than any other pool there ever has been or ever could be.'

And with that she returned him all the way back through the lands that the cruel upwind had driven him through, through the lands of the stars and of the Sun and of the Moon, and the lands beyond those lands, until he was once more on his waste and rocky island, with his Secrets, and with the colours he had discovered locked up in crystals among the rocks of his waste and rocky island.

And Joli gloried in this new Secret, which it seemed to him, you may be sure, was a greater Secret than any other Secret there had ever been or ever could be, and he would have kept it to himself except that it was too great even for him to add to his hoard. So he flew to the roosts of other islands nearby his in the great sea and he told them of the Knowledge of Life, so that now all of us possess that Knowledge, which is a part of the Dream of Qinmeartha.

We live for but an instant on the crest of a cataract. Before this life we are a part of a stormy river, and after this life we are all joined together in the pool that is greater and stiller than any other pool there ever has been or ever could be. The fullness of Life is not the instant we spend at the top of the waterfall, but also the before, when we are a part of the river, and the after, when we plunge to become a part of the pool.

Other dragons have since travelled to the land where Alyss dwells and which *is* Alyss, to the land that is beyond all other lands. Yet Joli was the first to do so, and the one to return with the Knowledge of Life, and so he is called He Who Flew Wisdom's Wings.

HOW THE GIRL-CHILD LoChi MADE OUR THOUGHTS REAL

THERE WAS A LESSER DRAGON born who from the moment of her first breath it was obvious had so much of the Memory of Qinmeartha in her that all realized she could be none other than the Girl-Child LoChi, She Who Seeks to the Ends of Roads, she who has always been to Qinmeartha as the stars are to the Sun. Even as she stumbled during her nesting days, the rocks near to her glowed with Fire for their love of her. She was the long-ago-died First Dragon Qinmeartha's token of fealty to the worlds he had created, and she held the flame of the stars in her pouch. The sky looked upon her and saw her as its own. The lightning sought her out to hear the tales she told. The Mountains-That-Roar were her sisters.

As she grew she was attended from far and wide by those who came simply to watch her, in that watching her they might learn what there was to be learned, and some proud males came also in search of pledges that she might bear their seed, for all that she was a Lesser and yet but a nestling.

But each and every day through her growing she maintained her silence, and each and every night the same; and those who sought to

give her their seed were sent away pledgeless by the elder dragons of
the Girl-Child LoChi's roost, for they scented her as the precious flame
she was. And they scented also where she had come from before she
had entered that egg out of which she had broken to come into the
World.

The truth the scents wove was this:

In breathing his Dream across all the swathes of the Void,
Qinmeartha gave of himself his entirety and died, leaving behind only
his Dream – which is all things – and his Memory – which is what lies
beneath all things.

Only not quite the entirety of his body vanished, for all things that
there ever were or ever could be are perfect only in their imperfection.
There were some small and slightest shards of him left over, smaller by
far than the tiniest drop of blood left drying on the rocks after a mating
combat, far too small to continue living on their own. These would
have died in an instant, bereft of the body of Qinmeartha that had
given them succour, but that they came together, like the still-bleeding
leftover scraps of a feast can be scraped into a heap and become much.
Even conjoined, these fragments of what had been great Qinmeartha
were not much; but a pulse of the soul beat in them when they were
added together, and that pulse of the soul was the Girl-Child LoChi.

The Memory of Qinmeartha knew that the Girl-Child LoChi
existed, and searched for her all through the old days and the new days
and the days yet to dawn, for it felt that she was a part of it even
though she was greater than it was, having a soul where it had none.
All crazed, the Memory of Qinmeartha searched on, and will forever
search on, for, until the Girl-Child LoChi becomes a
part of it, until the eternity that is eternity
multiplied by eternity makes the stars
dim and the flames of all voices
flicker, the Memory of
Qinmeartha will believe
itself incomplete
without her,
even though
this is false.

The Dream of Qinmeartha is full of peace, and is peace. The Memory of Qinmeartha is full of turmoil, and is turmoil. These are things that can never be changed for, if they were, then there could be no more change and there could be no more life.

So this is who the Girl-Child LoChi was. She was, long before she chose to enter the egg of one of us, the pulse of a soul that was, through its very smallness, greater than all there is that we can touch and know. She was a snowflake – which is beautiful and wondrously crafted, with angles that speak of the farness and shines that encompass all of time in a single gleam – against the snowfields of the Lands of Ice, which are but an aching white glare. If what she was could have been unravelled it would have woven a tapestry of thought portraying a small amount greater than all there was or all there ever could be.

But yet to those who came to watch her, and to

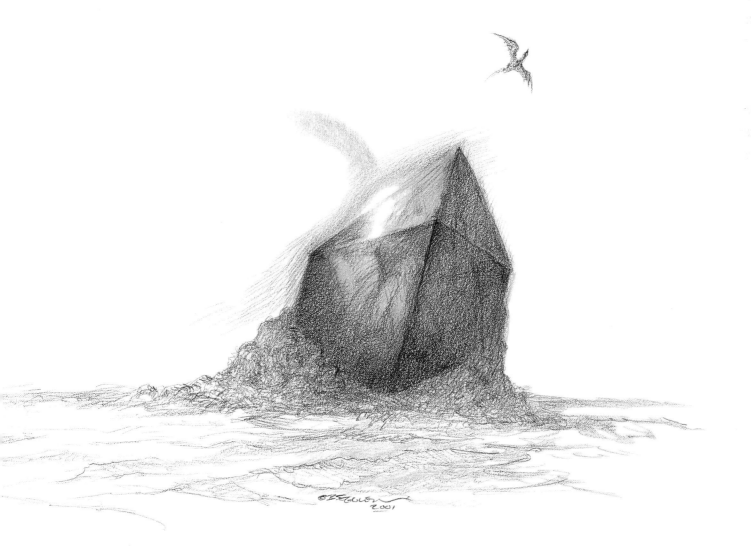

those who came to ask her pledge that she would bear their seed, she was seen as a nestling child who stumbled as she walked.

Those of her roost knew her as more.

They scented her thoughts, which were of the far places where a crystal made out of dreams can stretch a single facet of itself from one star to the next.

She grew and she grew and she grew.

One day she was a full-grown and she spread her wings, which were as cold as the rainbow and as hot as the vomit that spews from the throats of the Mountains-That-Roar. Her wings were greater than the sky yet hardly reached far enough to touch the sides of the nest in which she had been born. They shaded the sky from the Sun, and yet they hardly shaded her body.

In the moment of her adulthood she looked around her with a clacking of scales.

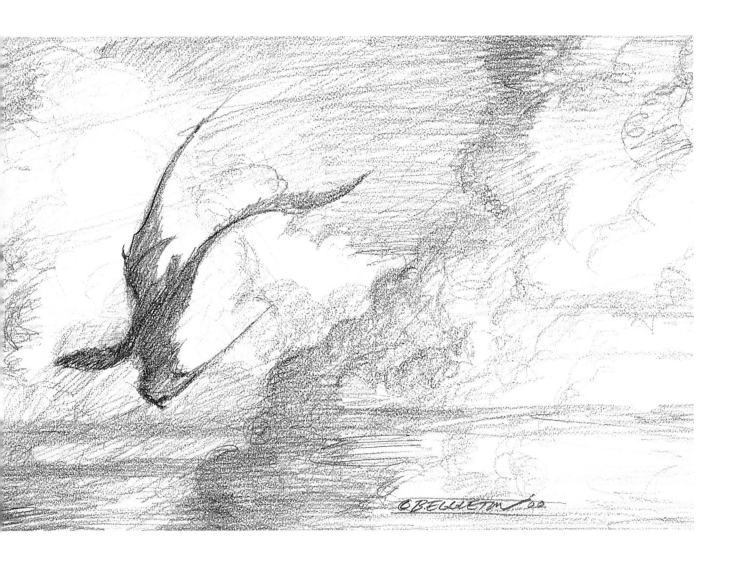

And she spoke for the very first time, which was perhaps also the very last time.

'This is where you wanted me to be,' she said. 'You drew me into the egg, and then later you forced me to break out of it. But I do not belong here.'

A flutter of her puny wingtips, and rocks shear from mountains halfway across the world, falling as sharp as the claws of anger to stab the plains below.

'And yet' – she breathes a plume of fire brighter than the Sun and whiter than starshine – 'I am a part of all wheres, which means that, wherever you may look for me, I am there to be found.'

She spoke true, although those who listened heard wrongly, seeing only the spread of her wings. Invisible though her true self was, it was indeed to be found in all things.

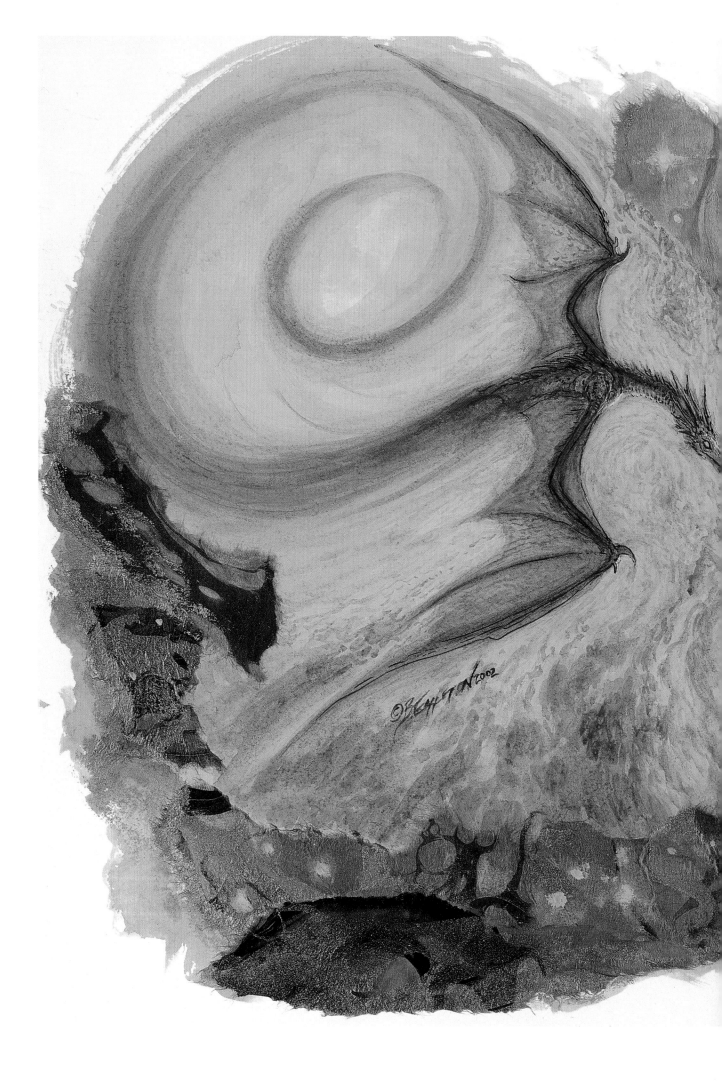

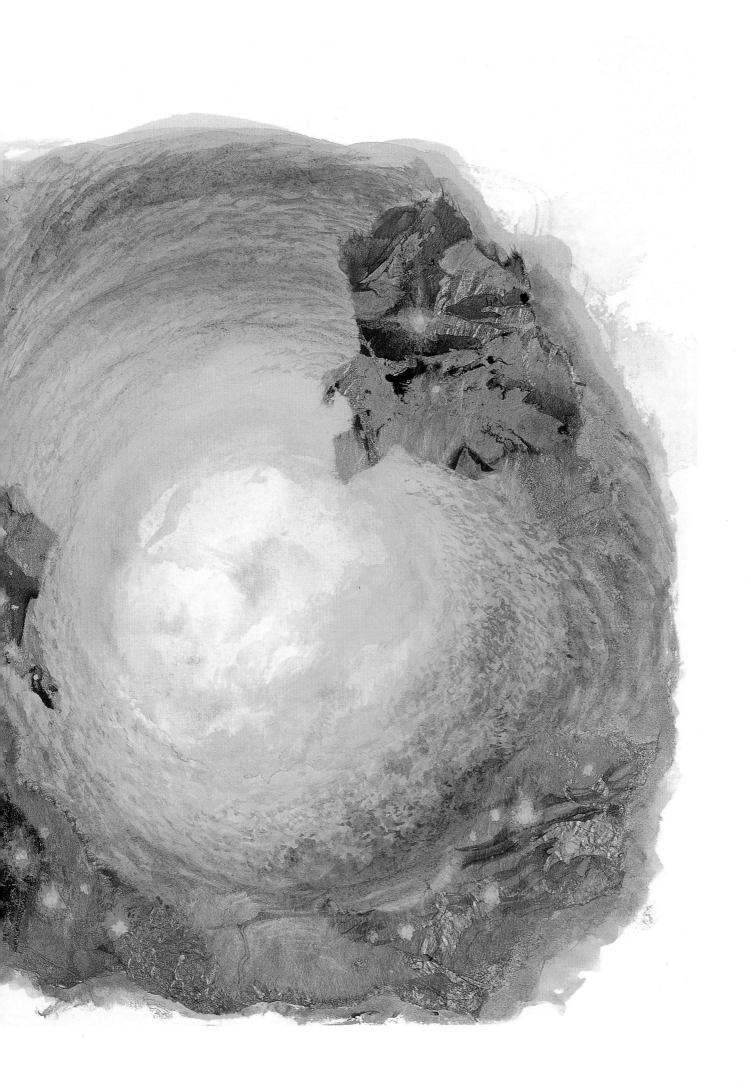

Then she soared up into the skies of summer, and before long was less than a speck upon the face of the Sun.

Through the cold dark lands above the air she flew for many a day until she reached the fiery land that is the Sun, where she swooped down to alight among the caverns of flame that are there. Her claws were unscorched as she trod upon the ground of the Sun and her eyes undazzled by the brilliance, for she was the Girl-Child LoChi, made of the stuff of Qinmeartha, just as the Sun is. She walked to the mouth of the nearest cavern, which she knew to be the Cave Where Dreams Are Kept, and shouldered her wings to enter it.

Inside the Cave Where Dreams Are Kept it was even brighter than outside it, and the sheets of flickering blaze that were its walls were filled with swiftly moving figments of the not-quite-seen, the pictures that we can descry only from the corners of our eyes and are gone when we turn our heads. Yet the Girl-Child LoChi could see them full well, and stared upon them as she stood on the floor of this great cavern, which stretches all the way to the heart of the Sun. In their darting flow she saw shapes and scenes that never were and never could be seen or told in the World of flesh and rock, and she saw them in colours that likewise never were and never could be seen or told in the World of flesh and rock.

She saw clouds that walked the land on long legs made of grass and flowers. She saw air that was spun of finest gold and laced with chalcedony, so that it could speak. She saw the Moon, but as a ring around the World that never rose and never set. She saw a bird with its head cocked at her, so that she could discern reflected in its ebony eye a land whose ground was pollen and whose mountains were bronze autumn leaves. She saw a tree whose roots were hissing serpents and whose branches were shafts of sunlight. She saw a butterfly that clasped the World between its wings, and, bearing it, flew to the World's own heart. She saw black snowflakes in the shape of dragon throats, which floated on streams until they became waterfalls of starry night.

All of these things the Girl-Child LoChi saw, and more.

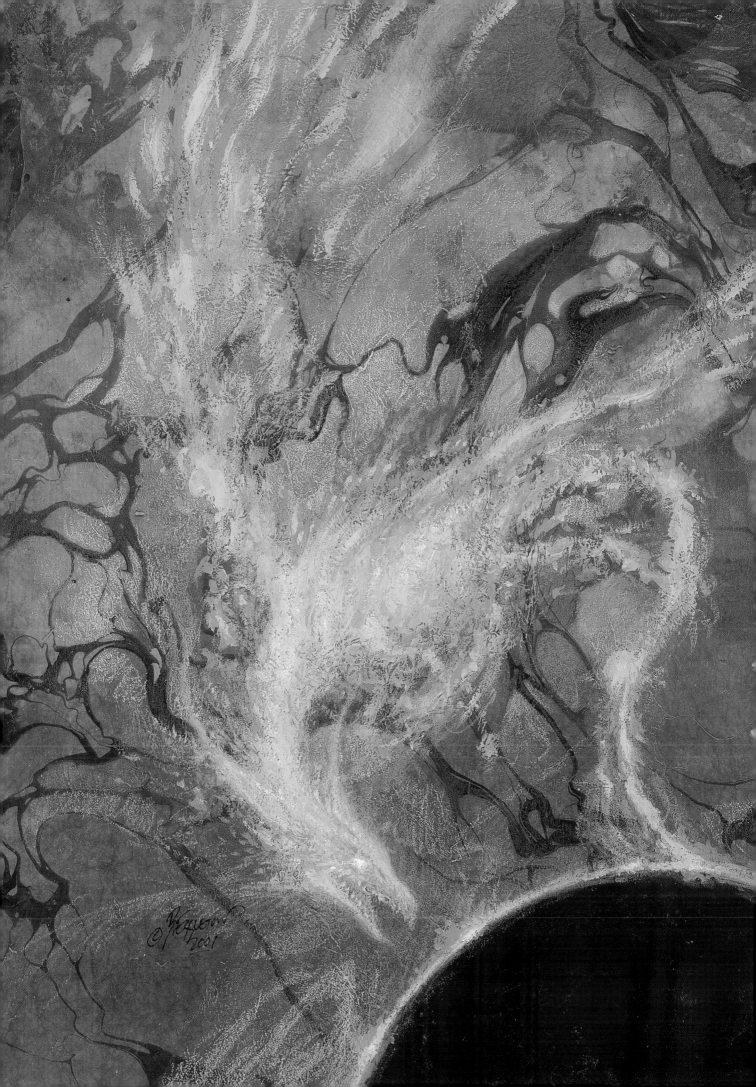

Some of these sights would have filled any heart but hers with fright. Some of these sights would have filled any heart but hers with awe. Some of these sights would have filled any heart but hers with marvel. Some of these sights would have filled any heart but hers with anguish. Yet she was the Girl-Child LoChi, made of the stuff of Qinmeartha, and so she felt neither fright nor awe nor marvel nor anguish but instead knew that through these fleeting mirages, moving in their fast but graceful dance, she was becoming better able to look upon the World.

Some of these sights filled her heart, however, with an emotion that was neither fright nor awe nor marvel nor anguish, but a feeling she did not recognize within herself. Yes, even the Girl-Child LoChi, made of the stuff of Qinmeartha, was puzzled by it. She tasted it with her mind, but could not know the taste. It was like the tang of salt

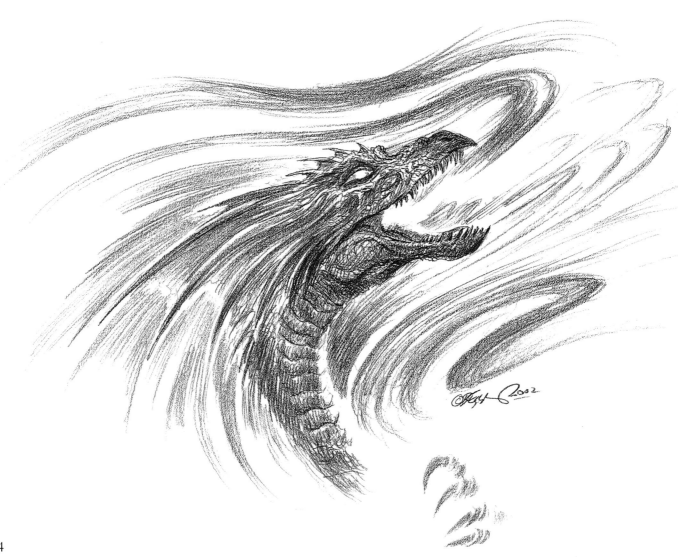

water brought by an imagining, but there was more to it than that. Its scent was the scent of air after lightning, which is also the scent brought by an imagining; but again there was more to it than that.

And as she probed it in this way she saw it as a stream of bubbles rising out of deep water and bursting on the surface, each with its own noise. Bubbles they were in their thousands of profusion, a torrent of small sounds.

The Girl-Child LoChi threw back her head and tried to copy the tumult of burstings with her voice. But the copy was a poor one, as spilt blood is a poor copy of the dawn. And she tried again, this time more loudly, adding more burstings, and more yet. Still the sound she made seemed weak to her.

At the last she gave a great bellow, spitting fire that was brighter and hotter even than the caverns of flame or the walls of the Cave Where Dreams Are Kept, and into this bellow she put every little pluck of noise from every little bubble, intertwined together to make a cloth that glowed and shone and shimmered, and that spread into the farthest eternity.

Once again she made this resplendent noise, and again.

And the sound of her laughter echoed all along the walls of the Cave Where Dreams Are Kept until it reached the very heart of the Sun, splitting off echoes like spears of crystal wherever it touched, until the whole of the Cave Where Dreams Are Kept itself was joining her in laughter.

Yet the sound of the cavern's laughter was more than the sound of her own. The echoes each sintered, some to make deep tones that quaked the soul, others to become the piping of insects as they call their mates. And, too, the echoes piled upon each other, until they throbbed with the slow cadence of breaking waves upon the shore, or like blood pulsing from a dragon as it dies.

This spate of sound too did the Girl-Child LoChi hear, and it filled her heart again with new feelings that she did not comprehend, save that they gave her pleasure. She listened to the echoes for long and long, until it came to her that she must bear these noises with her to the World, for they must not be left here among the caverns of flame on the Sun where none but she might hear them. So she gathered them into herself, swallowing them down into her belly and breathing them down into her lungs, until she had all of them.

Then she stepped from the Cave Where Dreams Are Kept and spread her wings and took flight from the Sun's impassioned surface, riding the currents of time that are in the great cold Void until the World was an eye before her. Then she flew down through the clouds. Then she circled three times above the mountain where her roost was. Then she glided slowly in to rest herself among her roost companions, who welcomed her with clacks and chitterings.

The Girl-Child LoChi did not speak to them. Indeed, she could not speak, for she was too filled with the echoes she had brought back with her from the Cave Where Dreams Are Kept; and she would never speak again, for beside the sounds she had heard in the Sun all speech would have tasted like rotting meat in her jaws. Instead she beckoned with her wings that her roost companions should stay back from her, and, opening her mouth, she released into the World the sounds that she had breathed and swallowed into her in the Cave Where Dreams Are Kept.

These sounds danced through the air, and they danced across the valleys and the meadowlands and over the slopes of the Mountains-That-Roar, and they danced to the burning lands of the World and to the places where there are only seas of ice, and they danced into the sky and down to the bottommost pits in the ground. And, everywhere that dragons heard them, those dragons were changed by them to see the World anew. For days did the Girl-Child LoChi set the sounds free, for so many had

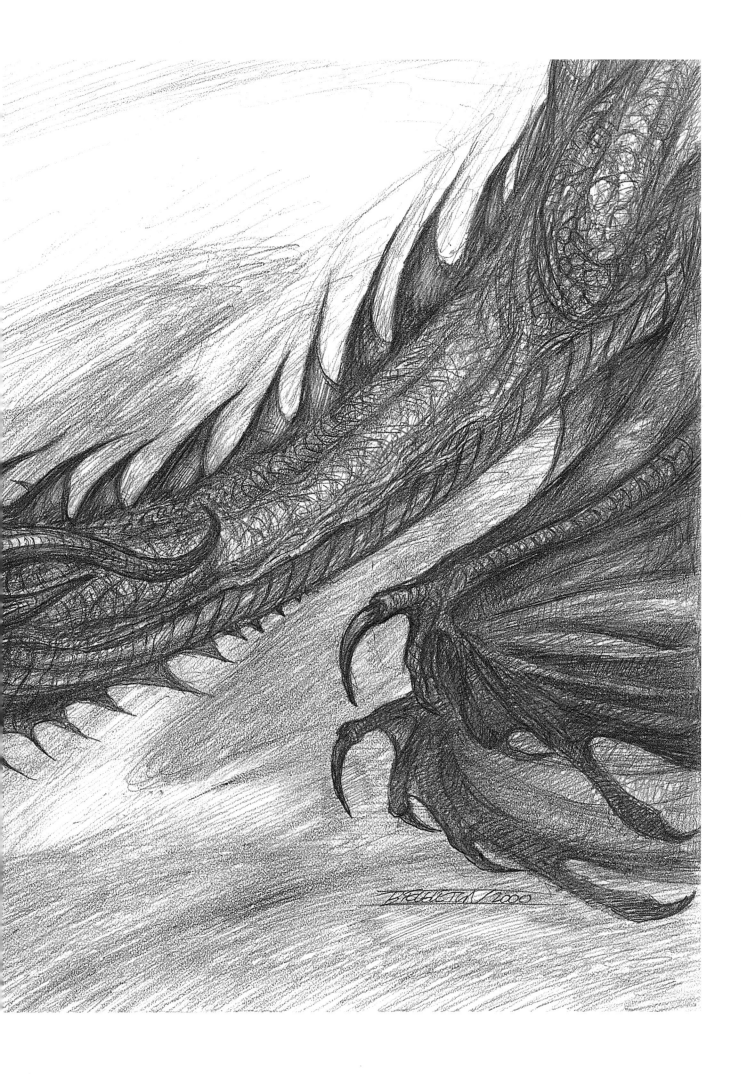

she swallowed and breathed, and there was enough of them to fill the World.

We can hear these sounds still, although they are so faint with age that only when all else is hushed can they come to our ears. But we breathe them and we swallow them without our knowledge, and often, as the Girl-Child LoChi did, we can set them free again, altered as they are by their having been within us, yet still with something of that very first noise the Girl-Child LoChi created with her laughter in the Cave Where Dreams Are Kept. These new and altered sounds are our songs, and when we set them free we are giving to the World not just something old as aeons but something fresh, which last is the essence of our souls.

Thus did the Girl-Child LoChi make our thoughts real, for without these two things that she brought back from the caverns of flame, the wit that makes laughter and the imagining that is music, our thoughts would be no more than dead leaves, stale and barren memories of the living thoughts that the first dragons once had.

Long did the Girl-Child LoChi's body live, and never did it speak, but sang or laughed instead. When finally she left that body, it went uneaten, and a thousand dragons bore it far above the air into the cold dark, where they set it afloat, sending it with their songs towards the Sun and the caverns of flame that were surely its true home.

Although this was what happened to the body of the Girl-Child LoChi, she herself is still in all things and everywhere, and most truly in ourselves.

And, all crazed, the Memory of Qinmeartha will forever try to seek her out, for, until the Girl-Child LoChi becomes a part of it, until the eternity that is eternity multiplied by eternity makes the stars dim and the flames of all voices flicker, the Memory of Qinmeartha will believe itself incomplete without her, even though this is false.

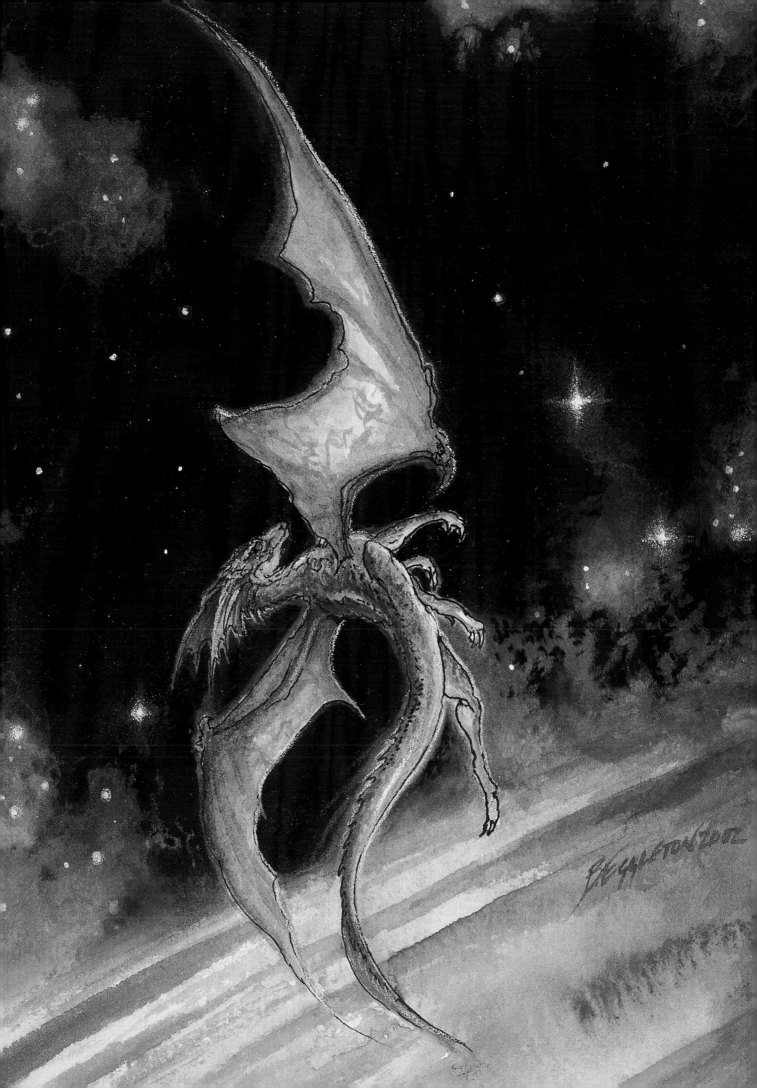

THE TWO ANYAS AND THE COMING OF THE ICE DRAGONS

WHEN THE WORLD WAS YOUNG there was most commonly great peace among our forefathers, who were greater than we are as is the forest to the tree. They carved valleys and raised mountains, and all the time they gave birth to populate the World. Once colour had come into the world, and the Girl-Child LoChi had brought also music and laughter, our forefathers used their breath to create great masterpieces of light and sound that were more joyous than any that ever were or ever could be.

Greatest of all these great masterpieces before the raising of Dragonhenge was the Moving Light of the North, which was painted upon the sky by the breath of a young fearless Lesser called Anya.

She looked upon her creation, the Moving Light of the North, and saw that it moved with the same pulse as her own pulse, dancing in the dark sky like spectral dragon wings, pale against even the light of the stars yet more alive than night clouds touched by the shine of the cold

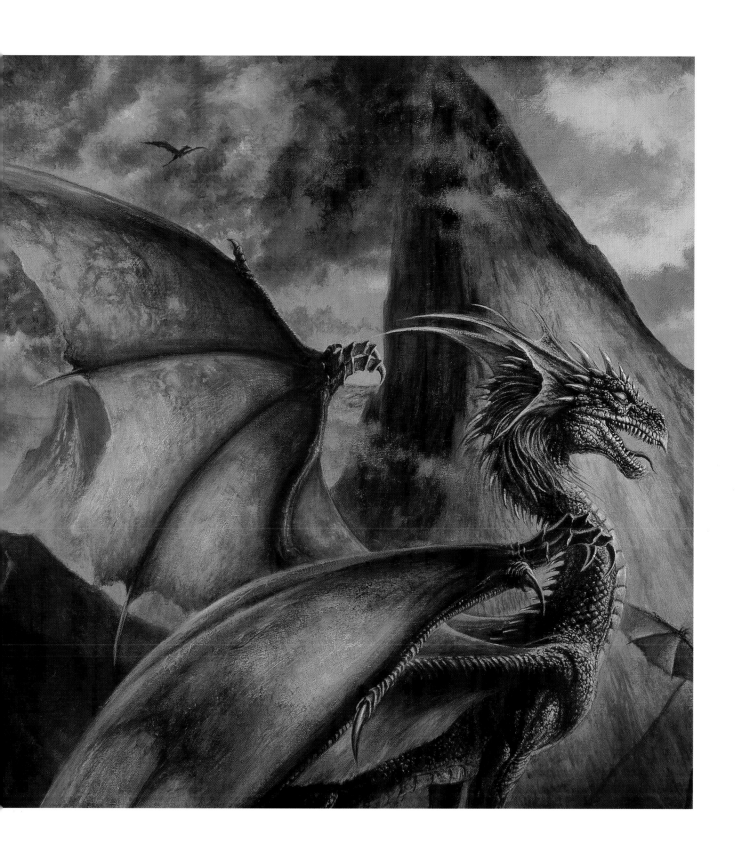

Moon. It was a flame made of living ice. And the chill music that it gave was the music of silence.

Anya felt love stir in her for the first time, and knew that the love was for her own creation, the Moving Light of the North. Each night she called to it words of love from her own rocky nest, as if she were a lover wooing an aloof adored one in a high eyrie, but it had no words for her in return. Each night she danced for it across the sky above the shade-filled forests and the black mirror rivers, but it paid her no heed: it just danced on in its own slow and silent way, dancing not for her but for the diamond starlight. She sang to it of the valleys that the Great Ones had carved out of the land and she sang to it of the Mountains-That-Roar and she sang to it of the Dream of Qinmeartha and she sang to it of her own dreams and she sang to it of the first breath of air in the morning as the Sun brings its fingers of warmth to the cold world, but all her songs went seemingly unheard. She let large tears of love form in her eyes, hoping that she could stir the Moving Light of the North into at least pity, but still it ignored her. And then she blew great flames across the land, conjuring wastes and forests alike to blaze so that the World became a beacon, but still the Moving Light of the North had no reply for her.

Those around her saw her dancing and heard her singing, and some of them mocked her for her hopeless love while others sighed for her pain, knowing that the love for the one who cannot be attained is the greatest love there ever has been or ever could be. All told her that she should forget the masterpiece she had made, the Moving Light of the North, and turn her eyes from the high skies to the low ones. But all she did in response to their kind or cruel words was spit fire or hiss fury.

A secret dream was born within the breast of Anya, as great a dream for her as the Dream of Qinmeartha was for the World. If her cold lover would not see her while she stayed in the low skies, then she must fly high to him, to where he could not fail to see her because of her closeness. Others had flown as high as or higher than this before her, she knew, for did not everyone know of Joli's flight beyond even the stars, yet still her heart near ceased its beating even as she thought of such a venture. The more she thought of it and the more her heart flinched, the more she knew she must not think of it; until, on the longest night of winter, still not thinking of what she desired to do, she took air on wings whose leather shook with her great fear, and she

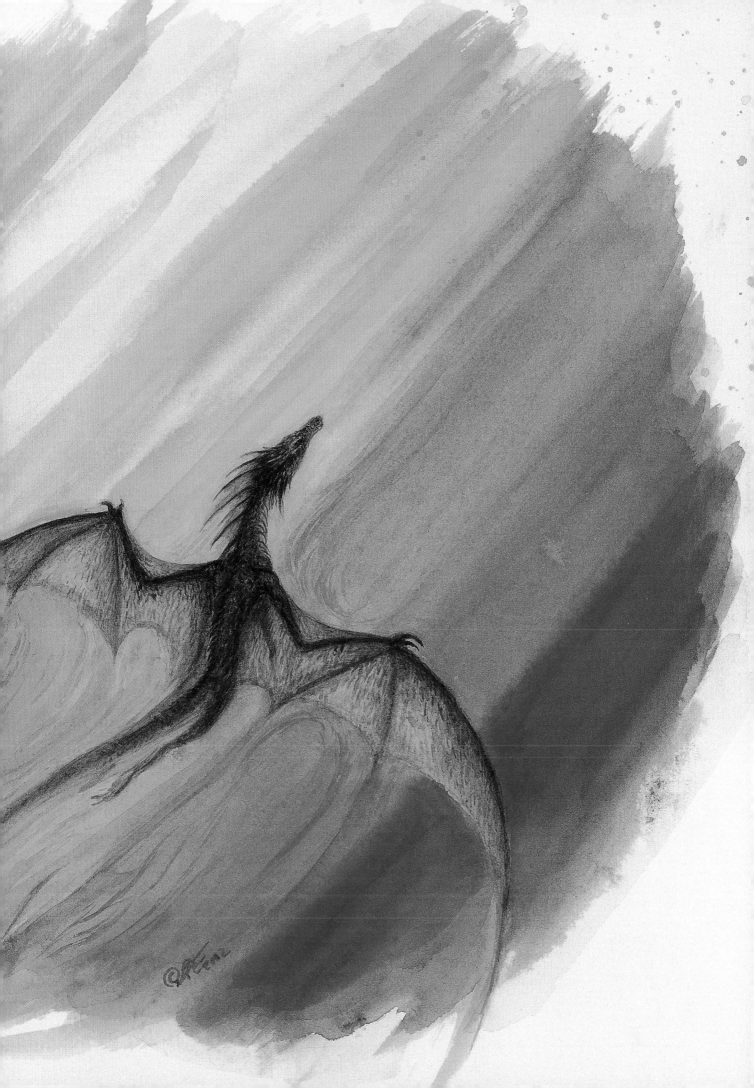

circled once and she circled twice above a great lake of frozen
moonlight, then climbed towards the skies and her loved one.

Clouds gathered from all around the World to form a wall to halt
her upward flight, but she beat through their barrier with angry flames.
Many of the Stars-That-Flare flew by her, whispering all their doubts
to her, but she refused to let their doubts become her own doubts.
A Star-That-Grows-A-Crest, its feathery tail spread across the heavens,
spoke to her in its gruff voice, urging her to turn back, but, although
she spoke back to it politely, she disobeyed its hoarse exhortations.
Three young male Lessers who knew her well and admired her for her
beauty and her strength of purpose followed her some small way and
tried to lure her back to the low skies, but she rejected their pleadings
and, one after the other, they fell away below her until she was alone
in the sea of darkness that is the high night.

There she breathed fire to give light to herself and to give
warmth to herself. She knew that the breath of a dragon is made up of
countless tiny dragons, each breathing fiery breaths that are themselves
made up of even tinier dragons, and so on forever; so her breath gave
her not just light and warmth, but as many companions for the journey
as she could ever have hoped for. She spoke to them as she flew higher
and higher, knowing they replied even though their voices were too
tiny for her to hear each one. All together, though, their voices were a
roar that made the stars tremble in their courses, and she took comfort
from this.

When the World was a coloured swirl beneath her, she ended her
circling and her climbing, and drove for the far North, where dwelt the
Living Light in the dreaming dance that she had given it. Over black
seas she flew, pocked by the sailing ice islands, until there was no sea
any more but just the glassy ice. And then she came to a place where
the darkness was utter save for the stars, and here it was that the
Living Light dwelt, for now it was large in her vision and the silence
of its music and its dancing large in her ears.

She came hovering before it and knew that it was vaster than she
had ever known while she was creating it, for it seemed to stretch
down to the World below her and up to the furthest rims of the Void
above her, and from side to side she could see no edges to it. No longer
did it seem to her as the ghosts of dragon wings; rather, it was to her as
if it were a waterfall of dreams that shielded this World from another

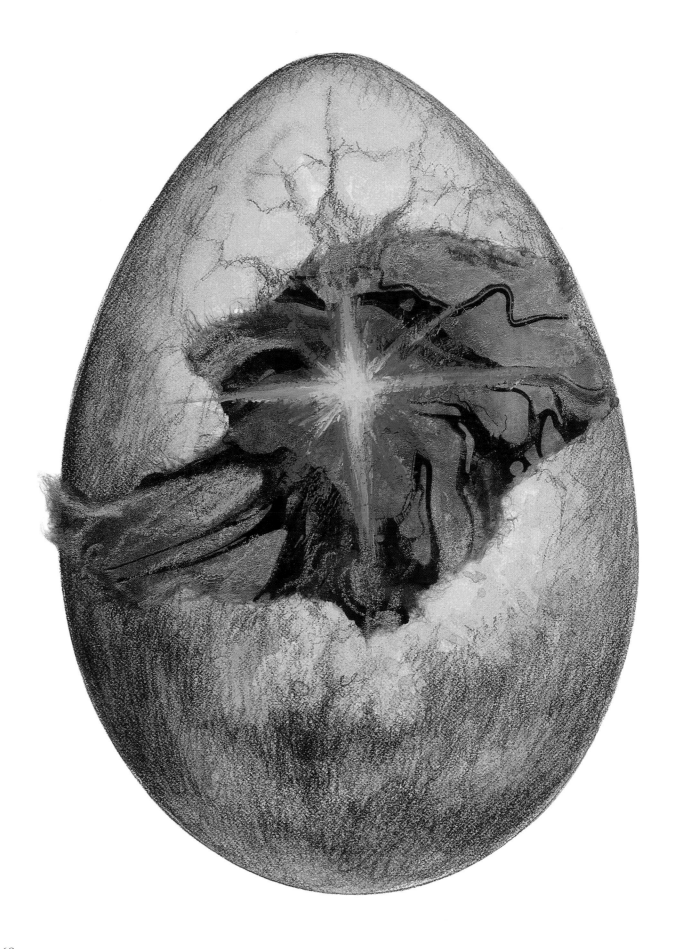

where thoughts were real as rocks in which music and light were bright streaks of ore.

'I have come to be with you,' she said to the Living Light of the North in a voice tamed by awe. 'It is something I have known forever, that we two are one, that we are destined to be together, the light of our love shining down upon all the World so that all may know of it.'

The Living Light of the North danced on, moving in steady, unerring time to the silent music that it made.

'I offer you as my love-gift all the greens and greys of the dawn of the day,' said Anya. 'I offer you the conversation of the leaves and the rivers' heartbeat. I offer you the loneliness of winter mists and the chatter of clouds' skidding shadows. I offer you the rages of lightning and the calm of sunshine on moist mosses. I offer you the length of a summer day and the scents of rain-creased nighttime. I offer you the glitter of split stone and the sombreness of a condor's flight. I offer you the eternal disputation that is life. All of these things I offer you as my love-gift, asking from you nothing in return but your love.'

Did the Living Light of the North pause for a moment in its

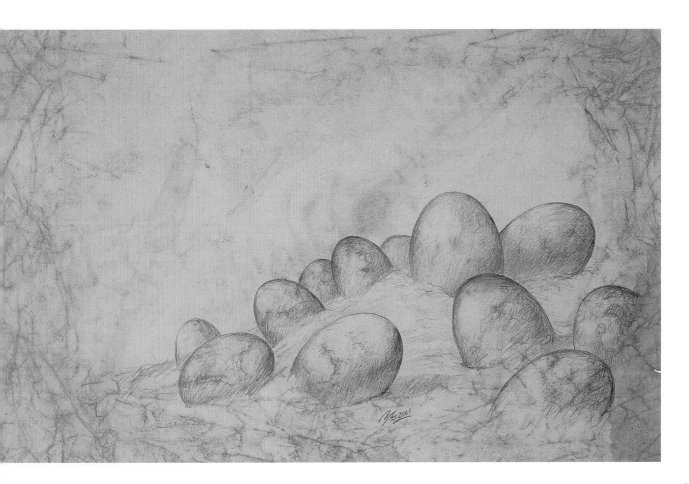

stately dance? She could not tell, but she thought not. It had a heart steelier than any preying dragon there ever had been or ever could be.

'And I offer you myself,' she said. 'For that is the greatest thing I have to offer as my love-gift.'

And this time the Living Light of the North did pause, for by offering herself she was offering it everything there was, and all her other gifts were made nothing.

Its voice pressed against her scales.

'Who are you to believe I have love to give you in return?' said the Living Light of the North.

'I am the one who created you with my own breath,' responded Anya, 'because my love for you was great enough.'

'Then, through loving me, you gave me love to give to you,' said the Living Light of the North in its voice that she could not hear but only feel pushing against her body. 'Yet, since I am only a tapestry of light created by your breath and not a truly living being, I have no passion, and so my love cannot last forever, as yours, but only for the rest of this long night.'

'Then the rest of this long night shall be our forever,' said Anya.

So for a quarter of a year, which was also forever, they embraced, dancing a new dance that had never been seen before and has never been seen since, and the light of their love did indeed shine down upon all the World so that all saw it, and to the heart of every dragon that there was came wonder and fear, for it had not been a part of the Dream of Qinmeartha that any dragon should find a union thus. Until the reluctant summer of those far northern places arrived were they together, and then

the shard of love that was all the Living Light of the North possessed waned, as it had promised, just as the dim sunlight crept across the oceans of ice below them.

Knowing herself no longer loved, Anya fluttered from the sky to land upon a crag of ice that stood proud above the rest. There she sculpted for herself a nest, melting the ice with tears of flame, for she could hear the crackle of new life within her. And so it was that she laid a clutch of a dozen eggs, and warmed them with her belly for the nightless summer long until the Sun began to be eaten by the horizon and she felt the eggs begin to split. Then and only then did she leave her children and fly upwards, ever upwards, to seek out the Living Light of the North in hopes of rekindling their love. Whether she ever did so is something no one knows nor can ever know, for from that day to this she has not been seen again.

Her children, left behind, were like dragons and yet they were not like dragons. They had scales and wings and thorny tails, and they had eyes that shone like angry rubies, but they were as white as the icy wastes around them and that had seen them

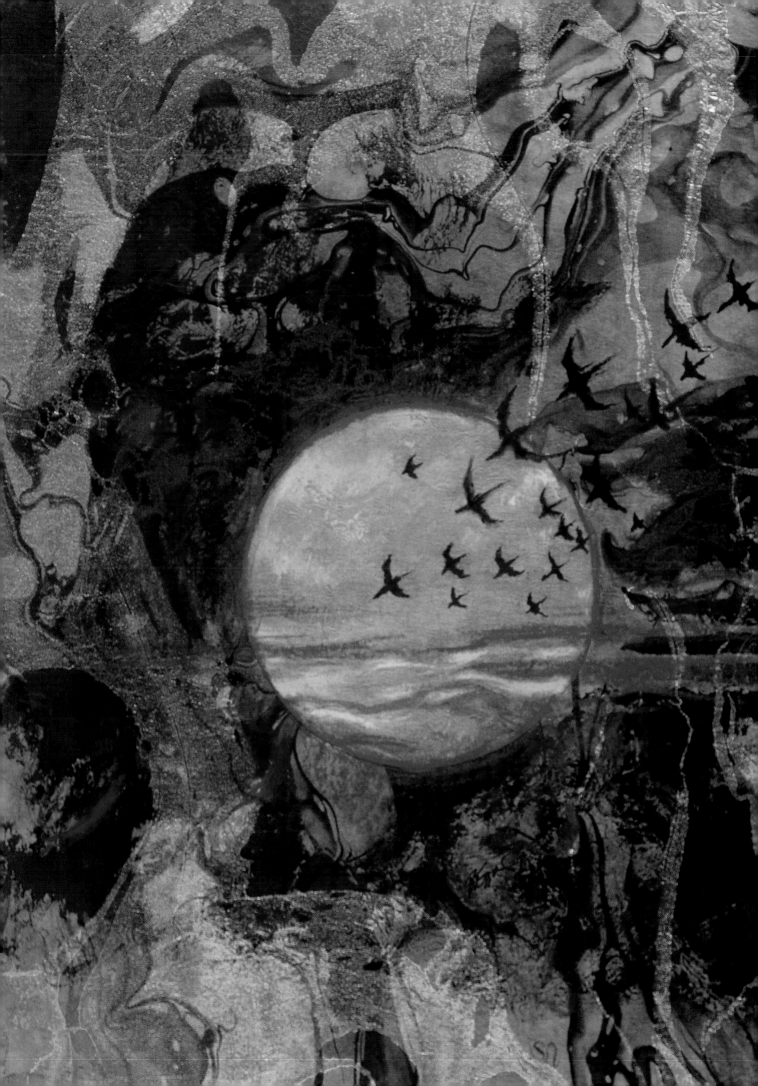

born, and the fire of their breath was the fire of cold, not the fire of the Sun. There were a dozen of them, and six were male and six were female, and they fought and squabbled and loved as young dragons all do before wisdom falls like slow rain upon them. They did not see mountainsides as they grew, nor trees, nor rivers, nor seas, nor the Mountains-That-Roar, nor valleys, but always the ice that is harder than rock and the Sun that is there for half a year and then flees for the other half-year, and the snow that the sorrowing sky weeps. For food they had only ice, which is why their breath burnt only with cold. The ice it was that gave them strength, and also their hatred for everything that was not them; for they knew nothing but themselves and hated all that they believed did not exist and could not be.

In their solitude and their hatred, they bred, and many generations passed by until there were uncounted multitudes of the ice dragons dwelling under the cold Sun and colder darkness of the lands that are the northern wastes. Then it was that one day one of their number, a proud and savage warrior called Garndon, saw flitting across the pale disc of the northern Sun the dark silhouettes of a flight of dragons that resembled his kin and yet resembled them not, and all the hatred that had grown through all the long generations did rise up in him, and he called out in a mighty voice for his fellows to gather round him, and he told them of what he had seen.

'They are abominations,' he said, sparking echoes from the ice shards that rose up all about them, 'and they must die, for their being desecrates the World.'

His fellows breathed icy assent that froze in the air to form statues of slaughter: here a dragon flayed of his scales while still alive, there a dragon spitted by a spear of ice and still writhing her agony upon it.

So did Garndon gather a host about him of the ice dragons, and they equipped themselves with daggers and swords and lances of ice, which they hardened to diamond with their breath, and they assembled upon a plain of ice that stretched as far as the eye could see and could ever have seen. Their shouting and their shrieks of hatred startled hail from the heavens above, and the lowering Sun shone red like blood upon their frost-gilt scales and their bitterly eager teeth. With a shrug of his wings that was louder than a command, Garndon lofted himself into the air, and in their thousands upon untold thousands they followed him until they covered the sky from one horizon to the other, so that the Sun could no longer see the World.

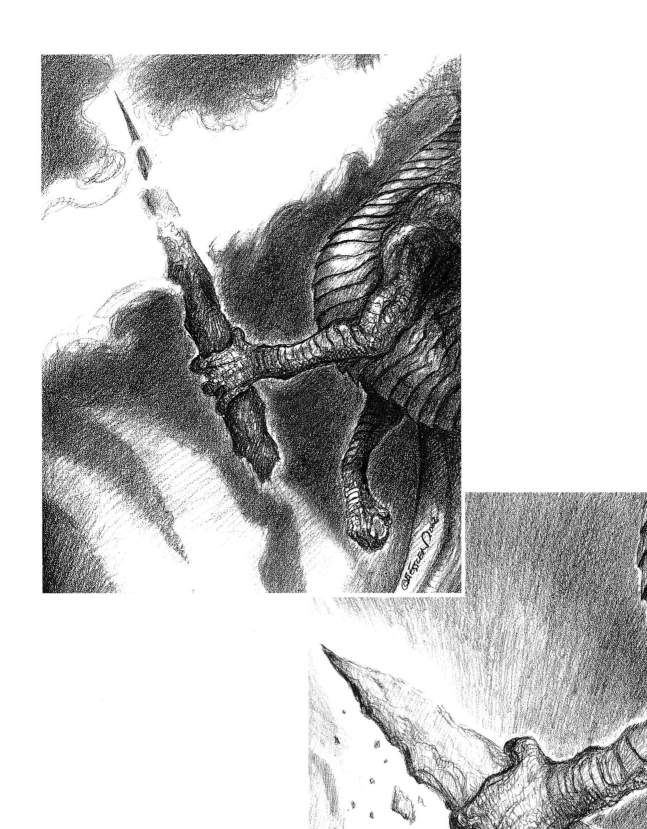

And south they headed. Over the glassy ice they flew, and then
over the black seas pocked by the sailing ice islands, until they came
to lands greened by trees and grasses. Wherever they came upon us,
in our ones and twos and hundreds, they fell upon us and rent us to
pieces with their claws and teeth, or froze us with their breath, or
hewed us with their diamond swords and lances and daggers. Many of
us they devoured, feasting for the first time that they ever knew upon
meat that was not ice. And they left only the limbs and lights of our
forefathers, those that they had not devoured entire, scattered across

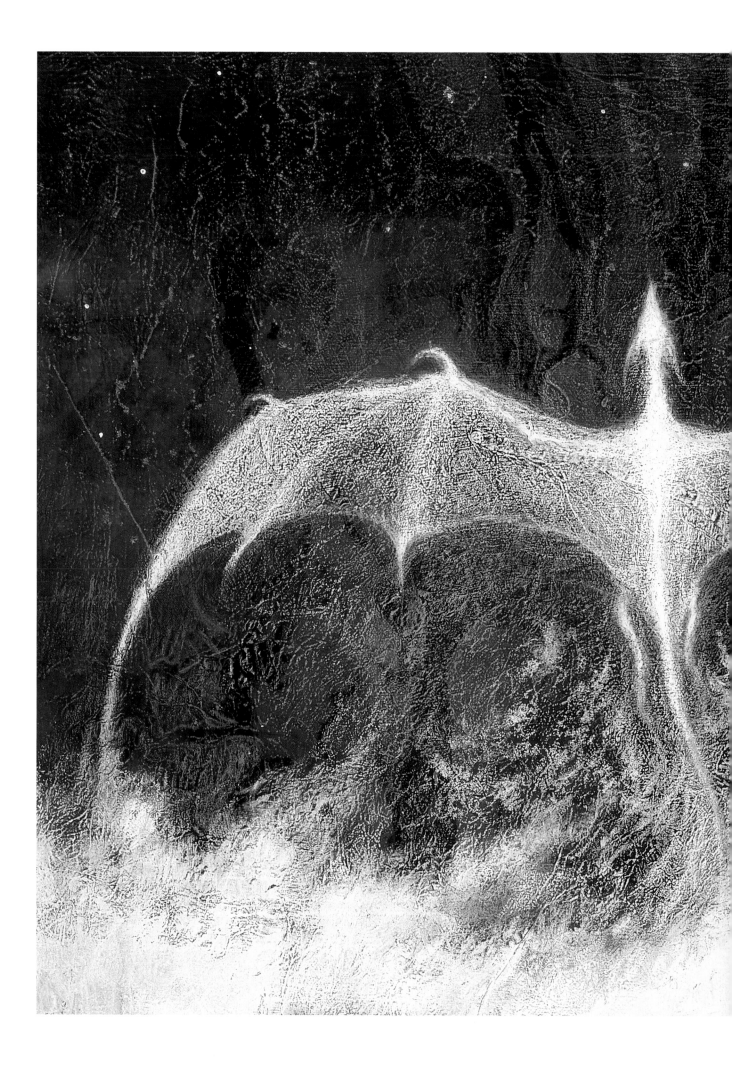

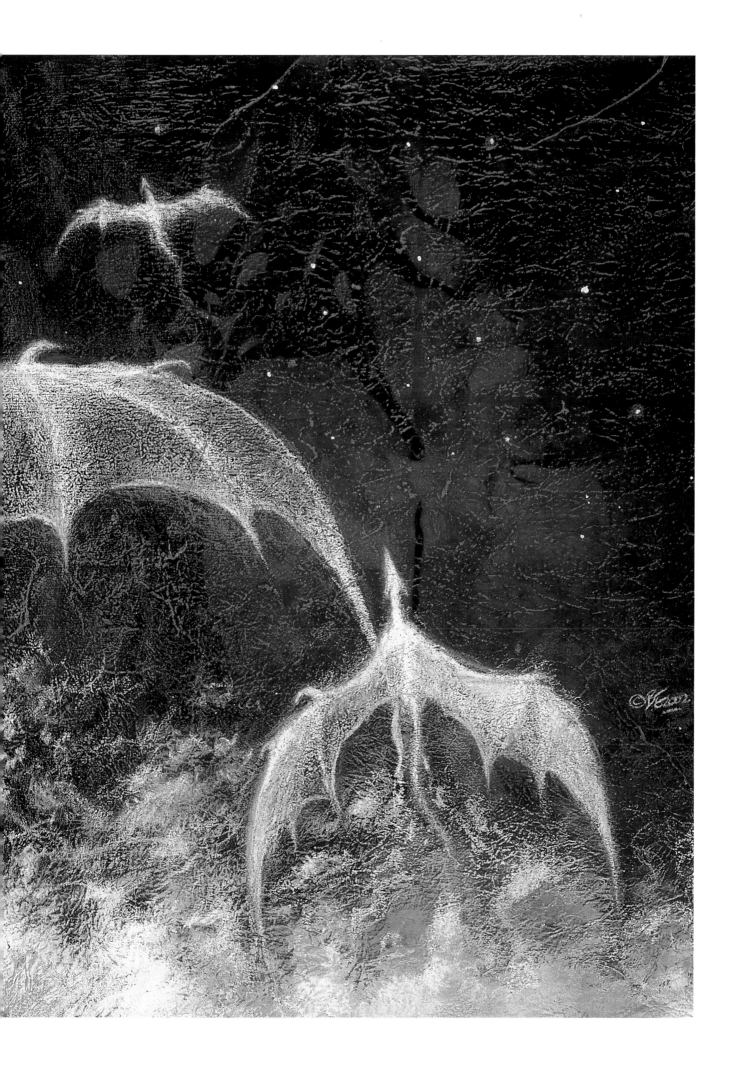

the mountainsides and valleys for the small animals and the birds to pick. Alongside the rivers and lakes of water there became rivers and lakes of dragon blood, which slowly hardened in the glare of the Sun to become the red rocks that are all the memorial there is for those who died. Even our eggs did the ice dragons shatter, sucking up their yolks as a great delicacy and minding not that each egg so destroyed was an unborn spirit deprived of its sojourn upon the World and its chance to fulfil the Dream of Qinmeartha. Foul and cruel were their crimes, such as none had seen before and none have ever seen since.

News of this slaughter flew south faster than even the ice dragons could fly, and it reached the ears of the dragons of the hotter lands, who fell prey to fear and turned in upon themselves and their nests, hoping that the vile plague of death would never come their way.

But among them was a young Lesser called Anya for her fearlessness. Though she could not have been of the lineage of the first Anya, who had given birth only to those who became the ice dragons now slaying all who lay in their dire path and leaving only misery and destruction in their wake, yet there were many about her who felt that her spirit was the same as that of the long-before Anya, for there shimmered in her eyes the light that shows there is nothing the dragon cannot attain. And, as Garndon had before her, she called out in a great voice and gathered about her a host of wrathful warrior dragons, Lessers and Greaters alike answering her summons.

'Are we just to wait here to be butchered?' she said into the warm wind that swirled. 'Will we betray all the dreams of those who have gone before us, even the Dream of Qinmeartha himself? And are we to betray those who should come after us? Will we bow our heads meekly to Evil and die in a blaze of shame?'

Though none had heard the word Evil before, all knew its meaning, and they shouted angrily to the heavens that they would follow her in defence of all that was good even to the highest eyrie of all, the

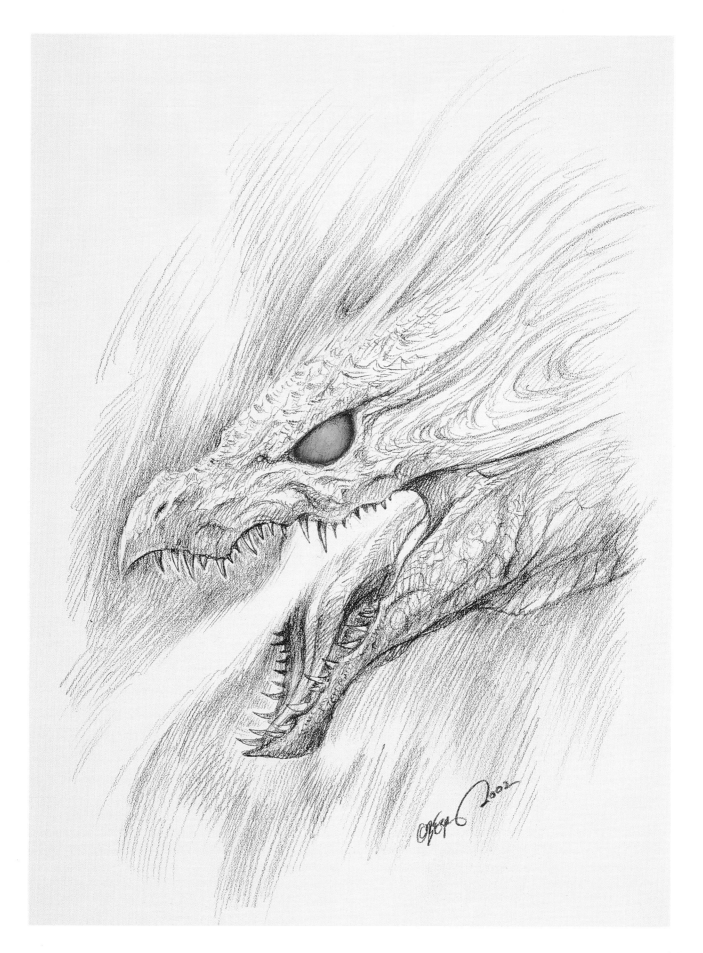

eyrie that is Death. Better by far to go to the eyrie of Death for the cause of Good than to be conveyed there by the wings of Evil.

'Remember she who flew all the way to the skies, even though they said she could not!' cried this new Anya. 'Remember she who even though long gone from the World gave me her spirit to have as my own! Take as you need of her strength from me, my friends, for we shall fly north to meet this cursed horde.'

And they did indeed drink of her strength, or of the strength that she had been given, and still Anya herself was no less strong, but was the first of them to take to the air. And in their thousands upon untold thousands they followed her until they covered the sky from one horizon to the other, so that the Sun could no longer see the World.

To the north they headed, drawing ever more of our forefathers to join them until the sky was filled a hundred layers thick with beating wings. They bore with them swords and daggers and lances they had fashioned from the branches of the forests and fire-hardened with their breath, or from stones they had split apart with smites of their claws. And still more joined them, until the sky was filled a thousand layers thick with beating wings.

At last Anya came upon Garndon on a coast where the greatest ocean there is or ever could be beat against the sides of mountains so tall they ripped open the clouds' bellies. These two hosts, neither greater than the other – the heart-chilling white hordes that cackled behind Garndon, their jaws dripping with the blood and yolk of the innocents they had slaughtered, and the many-coloured hordes that trumpeted their fiery defiance behind Anya – faced each other while the waves churned beneath them.

Anya cried out her defiance in a voice that shook deluges of snow free from the mountain pinnacles to crash like thunder into the valleys beneath, and these were the words she said:

'The Dream of Qinmeartha is that all dragons shall live in peace and fellowship, and in return shall be given the waters of the World to drink and the humble creatures to eat and the air to breathe, so that we may work to bring his Dream to ever greater fulfilment. This is Qinmeartha's Law. All who disobey it, all who seek to destroy, will be cast away from their lives in the World.'

'We obey no dragon's dreaming,' cried Garndon in a voice that drew up the waves until they were near as tall as the mountains and that made spinning winds dance along the shore, tearing sand and rocks away into their dance. 'The true home of all true dragons is the icy waste, as it has always been and always will be, and all who claim to be dragons yet populate the despised realms of the warm are shams and mockeries and abominations that must be destroyed if the World is to be clean.'

With that the vile leader of the ice dragons plucked up some of the greatest of the mountains in his clawed fists and hurled them at the Moon, which was watching far above. And the mountains struck the face of the Moon, as we can all still see today, so that it no longer had the unblemished beauty of the Sun.

In response to his gesture of hatred the dragons behind Anya turned their faces to the heavens and blew flames that set fire to the clouds and brought a million new stars into being.

Anya took the first of her lances, which was a tall pine tree torn from the ground and made harder than stone by the fire of her breath, and hurled it at Garndon's chest. He swung easily in the air and the weapon flew past his chest to impale one of his warriors, who fell on the backs of those beneath him, so dense were the hordes in the sky.

And all at once the dragons of the warm lands fell upon those of the north, and all the World was filled with cries of savagery and wrath and agony and fear. For the ice dragons, whatever their Evil, were dragons still and were not weak and were not cowards, and fought back as hard and as bravely as any could have asked. Many died in that first wave of attack, and their spirits rose to the highest eyrie of all, the eyrie that is Death, until the eyrie could hold no more.

Then Anya took the second of her lances, which was a needle of rock scraped in a single strike of a Greater's claw from the side of the tallest mountain in the World, and hurled it at Garndon. But again the warlord of the ice dragons swerved easily in the air so that the weapon flew past his loins to impale one of his warriors, who fell on the backs of those beneath him, so dense were the hordes in the sky.

And now the ice dragons flew to the attack, falling upon the dragons of the warm lands and enacting upon them a dreadful though evil vengeance for what had gone before. Yet the dragons of the warm lands were no less full-hearted than those from the northern wastes, and, while they perished in their thousands, as many of the ice dragons died with them. And the spirits of all that were slain rose up towards the highest eyrie of all, the eyrie that is Death. But that eyrie could hold no more, for it was full of the spirits of those who had died before them in the battle for the World, the greatest battle there ever was or ever could be, and so these new spirits were turned away to wander among the stars, where they added themselves to the number of the Stars-That-Grow-Crests, which can accordingly be either good or evil or merely passing wayfarers, as they are to this day.

The hosts of Good and Evil retreated from each other. So many had died in the two onslaughts that now the sky was not filled a thousand layers thick with beating wings, nor even a hundred, but only a dozen, and in places the Sun pierced through to glisten upon the seas and the lands of the World.

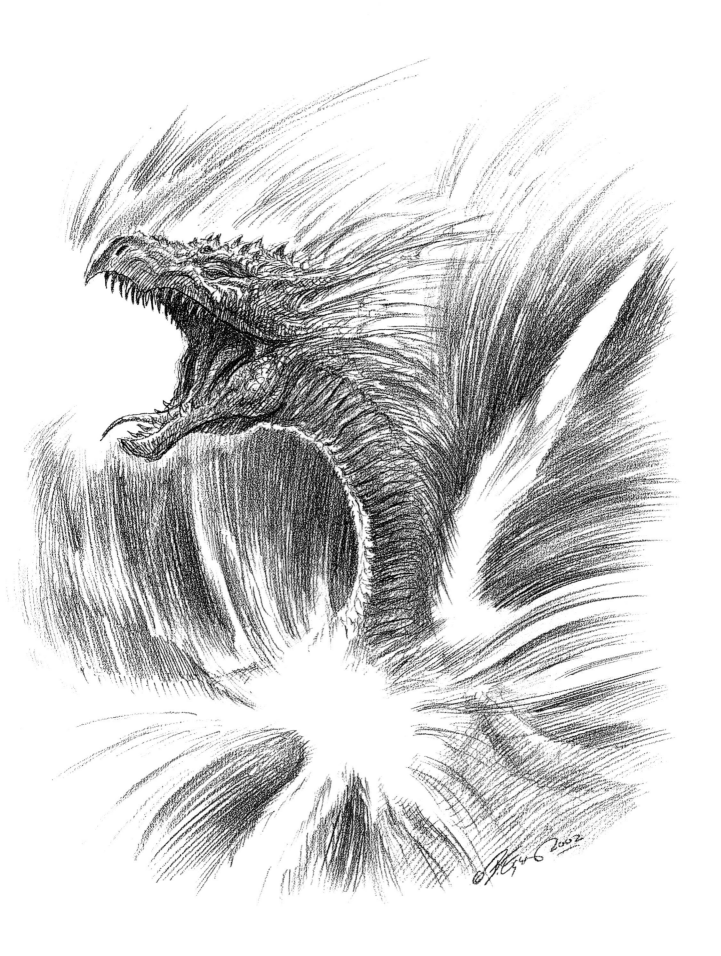

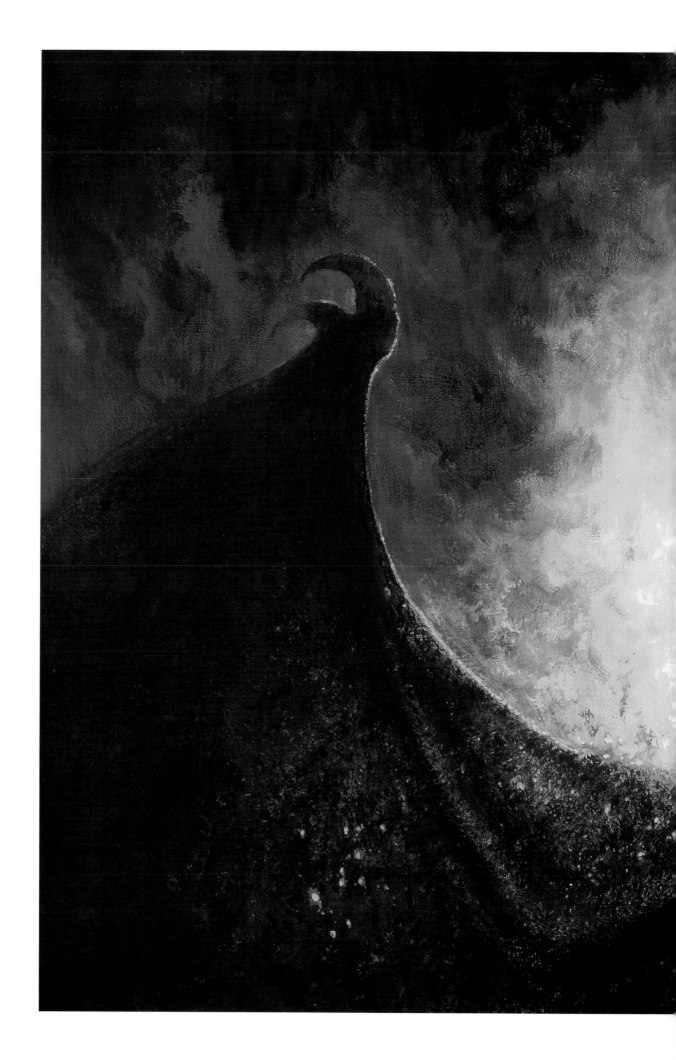

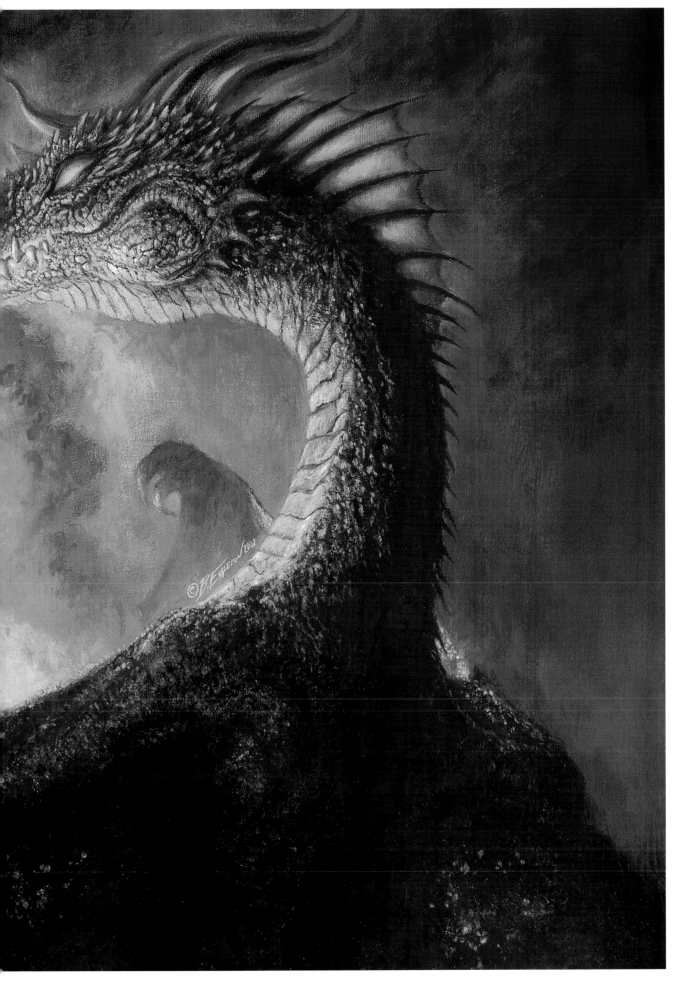

85

Then Anya took the third and last of her lances. This was neither a tree torn from the ground nor a needle of stone ripped from a mountain's flank, but instead it was a lance she had fashioned herself from her breath and her vision and her fearlessness, from the light reflected off a still lake, from the cries of new-hatched dragons, from the serene music that is made by the Moon, from the peace of the rainbow, and from the joy that fills the spirit at the first sight of a green-fringed valley between sprawling hills. It was a lance too bright for any dragon's eye to look upon save that of its maker, so that, this time when she hurled it at the hated figure of the leading ice dragon, Garndon, he saw nothing coming towards him except a shard of sunlight, and he failed to move aside. The lance struck him through his heart, which was made not of flesh but of ice and hatred, and he screamed a scream that could be heard all around the World, and by the Sun and the Moon and the stars, a scream that can still be heard in the howl of the destroying wind as it lashes the waves into fury.

But even as Garndon died, so did the third and final lance of Anya, the lance that she had fashioned from her own essence, strike at the hearts of those around him. Many thousands of them perished in that moment, but still there were many thousands left, and these, knowing that there was nothing awaiting them but Death unless they could somehow prevail, swarmed with hideous cries towards the hordes of Anya, who had grown slovenly in their own defence now that they thought the battle was ended. The dragons of the warm lands swiftly rallied, but not so swiftly that thousands of them did not die before the last of the ice dragons of the northern lands was cast down from the air to perish upon that bloodied coast.

The spirits of all who had died in the greatest battle there ever was or ever could be ascended to the highest eyrie of them all, the eyrie that is Death, but they found it full to bursting with the spirits of those who had died before them, and they found that the sky too was full to bursting with new Stars-That-Grow-Crests so that it could accept no more of them. And so these last of the spirits of the warriors fell back towards the World, coming to ground in many places all around it. There those spirits even today lie where they fell, and we can see and hear them. The spirits of the dragons of the warm lands become new, young Mountains-That-Roar, and still can be heard as they spit their lusty, life-filled defiance of Evil to the skies. And the

spirits of the ice dragons became
the rivers of ice that squat among
high mountains and by the chillest
seas, and which also roar, in a long,
low grumble that makes the heart
cold, of the Evil that they sought
to bring about; or they went deep
within the ground, where still they
roar and heave the land with their
hatred, causing great destruction.

Few were the dragons that
Anya led back to their homes in
the warm places, and all of them
were sorely wounded, their wings
torn to tatters and their throats
and bellies dripping blood, yet
they bore their wounds with pride,
for did they not know that they
had saved the World from the
hordes of Evil, and that they had saved the lives of all who had
remained behind and all the dragons who were as yet unborn?

So it seemed to them, at least, but Evil, once engendered, is not
so easily extirpated, and it still lurks in the World and in the hearts of
all too many dragons, as we do know. Thus Anya, while victorious over
the forces that Garndon had mustered, knew even herself that his dead
spirit had gained a minor triumph over her: while the ice dragons had
been driven from the face of the World, the Evil they had brought with
them – the Evil that is blind and unreasoning hatred – could never be.

So Anya, while she never lost her fearlessness, ever after carried
also humility within her. It is these two entwined that she, many
generations later, will express through the greatest masterpiece there
ever was or ever could be.

Her creation, Dragonhenge.

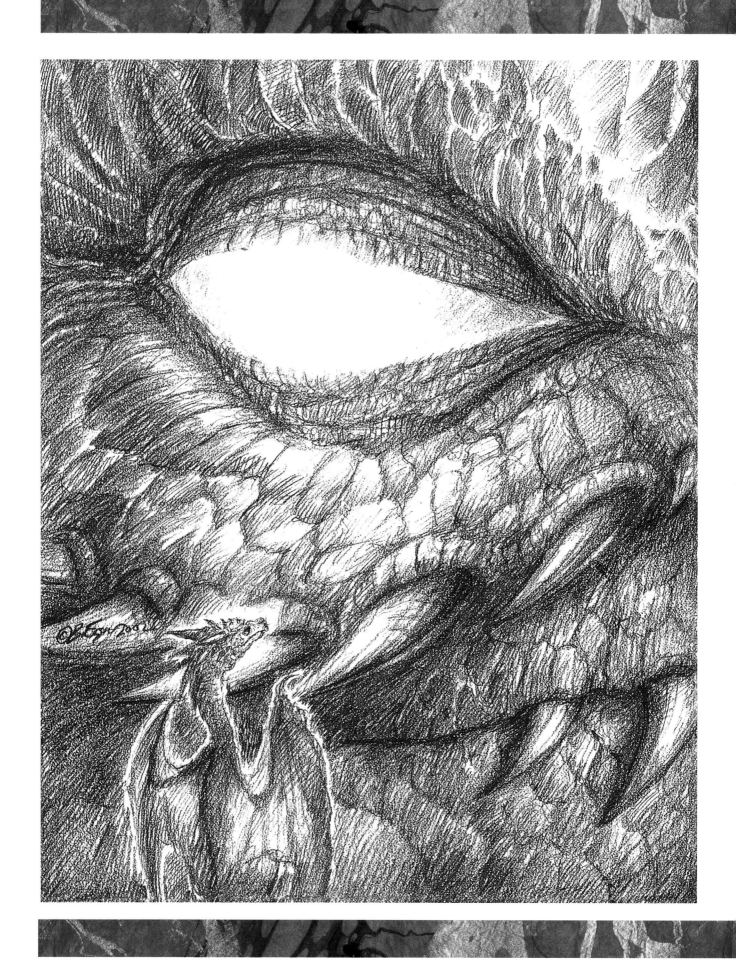

WHY THERE ARE NEITHER GREATERS NOR LESSERS

MANY WERE THE GENERATIONS of us that rolled past after the World had fallen out of the Breath of Qinmeartha, as the giant dragons of those days roamed the land shaping it to suit the Dream and to suit their own vision. But they altered the land more than they could ever imagine altering themselves, for they held that, as they were now, so was the intention of Qinmeartha, and should remain so forevermore. Those who sought to change the ways of the dragons were banished, or punished, or slain, for thus was the harsh code of those times.

You look upon roost-fellows in their nests today, and you see the younglings playing snap-games among each other, and, as they grow and strive each to surpass the next in glory and beauty, they are still, first and foremost, brood companions and blood friends, ready to fight until the nearly-death against each other but also ready to fight to the very death to defend a roost-fellow from an aggressor or any other danger.

It was not always so.

Once, nestlings at their very hatching would be separated by the judgement of the greatest of the land. Some were adjudged destined for might; others would be deemed to own small and undistinguished

futures. In accordance with these judgements, the dragons would live out all the rest of their lives in splendour or in dimness. They commanded, or they lived in servitude to those who did command: they were Greaters, who were glorious, or they were Lessers, who were barely above the humble creatures of the World.

Some Lessers attained high eminence, through their intellect or their cunning or their wisdom or simply their good fortune, but even so they were ever Lessers, no matter their renown or worth. And that was the way it was.

One of the greatest of all the Greaters there ever was or ever could be was of such grandeur that he was called by many names at once. He was Barra 'ap Rteniadoli Me'gli'minter Rehan, which means that he was Rehan, More Awesome than the Winter Skies, the Reborn Offspring of Rteniadoli (who was himself the offspring of the Sun and Moon, as you well know), and The One Whose Wings Masked the World in Their Shade. These names did not tell entire truth, but were a tribute to the respect in which he was held by all the World.

In one of the many roosts he kept in every land there was born a Lesser who was less than any could remember, a small black dragon who at her hatching it was not thought would live. Her name, when any could recall it, was Angrboda. Even as she grew through her early years, Angrboda seemed never more than a wingbeat away from death, for she was frail and showed her bones through her dark unshining scales. Her roost-fellows treated her as if she were already dead. So starved of food was she by them that sometimes she chewed the fabric of the nest, finding what nourishment there she could. They buffeted her with their wings whenever she tried to talk or join them in their snap-games, beating her back to the dark corners of the nest where only the vermin dwelt – those vermin, when she could seize them, being what really kept her alive. Even her roost-mother thought nothing of this least of all the Lessers, and shunned her; while her roost-father, great Barra 'ap Rteniadoli Me'gli'minter Rehan, knew nothing of her at all.

There came a scourge upon the dragons of the World, a plague of the Disease-that-is-Despair, the ailment that causes even the strongest of us all to waste slowly away until we are but dust for the winds to raise in dance. No eyrie, no nest, nowhere was safe from it; some said that even the Sun was seized by the Disease-that-is-Despair, and it is true that its eye was dim for months as it gazed upon the World.

The Disease-that-is-Despair respected neither Greater nor Lesser

in the campaign it waged, and among those it assailed was Angrboda's own great roost-father, the mighty Barra 'ap Rteniadoli Me'gli'minter Rehan.

When Barra'ap Rteniadoli Me'gli'minter Rehan felt the Disease-that-is-Despair first send its creeping patrols into him, he took himself to an eyrie far up the mountain from the nest he fathered, for fear that the Disease-that-is-Despair might pass from him to his offspring, his mates and his brothers. And there he settled himself that he might gaze out across the land to where the Sun bedded itself beneath the ground in a pool of fire. No beauty did he see in that vista, no grandeur, for his own heart was bulged with despair until it was vaster than the swollen orb of the Sun.

Those dragons of his roosts sorrowed for him, but they left him

alone in his combat with the Disease-that-is-Despair, saying that this was his wish – which was surely the truth, for had he not said so much before his departure?

Truth it might be, yet it was not all the truth, for in their secret selves there stole the fear that the Disease-that-is-Despair, in conquering Barra 'ap Rteniadoli Me'gli'minter Rehan, might seek further conquests, and lay siege to any who were close to him. So they sat in the nest and chittered of the woe that was upon them because of the ordeal of Barra 'ap Rteniadoli Me'gli'minter Rehan, and his sufferings. And they consoled each other that there was nothing could be done to ease his ills; indeed, that by letting him cast himself into loneliness they were aiding him more greatly than might be done in any other wise.

Small Angrboda was no part of these discourses, for she was too insignificant to be noticed by the others of the brood, save when one or other might say they wished it had been Angrboda smitten, not the lofty Barra 'ap Rteniadoli Me'gli'minter Rehan, their roost-father.

And, being no part of these discourses, she perched herself upon the wall of the nest, and gazed up the mountainside toward where her roost-father, the great Barra 'ap Rteniadoli Me'gli'minter Rehan, lay in silence and in stillness. And the sadness that was in his heart seemed a touchable thing to her; and where others chittered emptily she wept for him. Then, ignored by all around as was their practice, she slipped from the woody wall of the nest and stretched her stringy black wings either side of her bone-prick-led body, and flew to

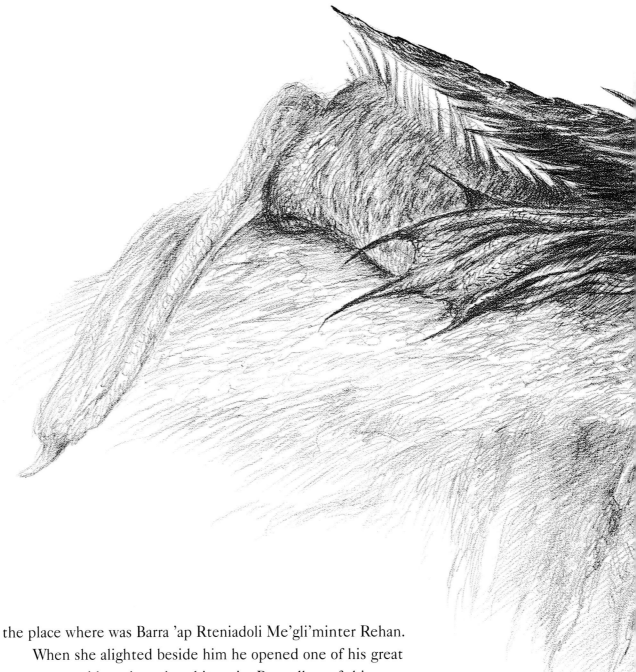

the place where was Barra 'ap Rteniadoli Me'gli'minter Rehan.

When she alighted beside him he opened one of his great eyes to regard her, then closed it again. Regardless of this sign of dismissal, she crept toward him – her bones rattling and scraping as she crept across the cracked bare rock – and, fearless of the Disease-that-is-Despair that ravaged him and might all too soon move to ravage her, eased herself under the place where his wing met the lower side of his chin, for he was so much vaster than she that there was space in plenty there for her to couch herself. And, once there, she spoke to him in her small voice.

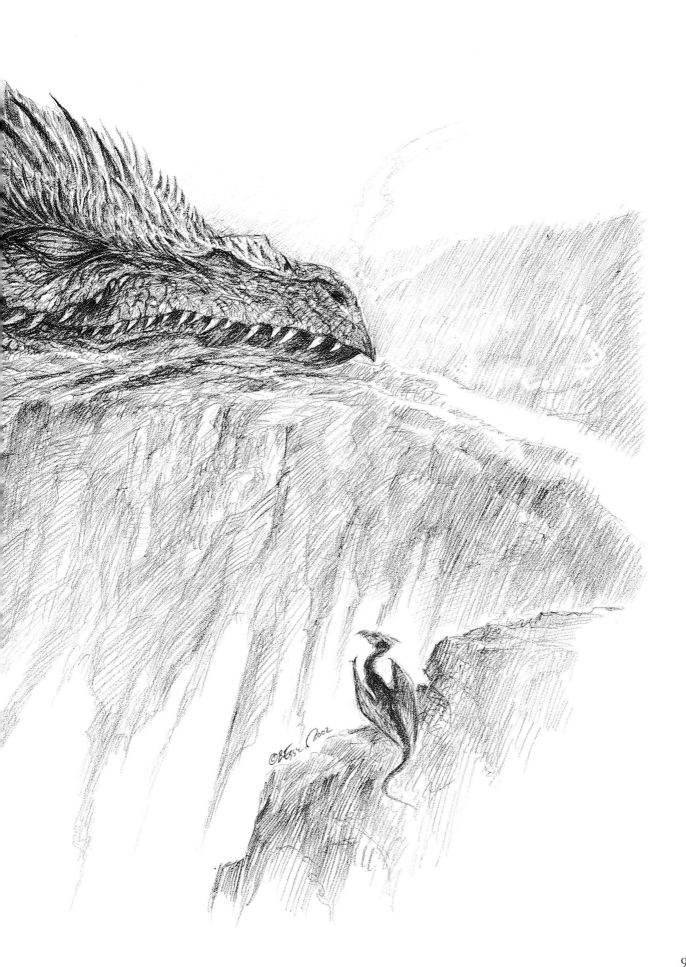

She spoke to him of the way the light touches the tips of the waves, making them into shards and spikes of the crystal that glistens. She spoke to him of how the wind makes the top of the forest into a green ocean. She spoke to him of how it seems that even mountains must die so that they can ride the air as fleshy white clouds. She spoke to him of the clarity of fallen snow, and of the rejoicing that is the rush of ash down the slopes of a Mountain-That-Roars. She spoke to him of the sanctity of cobwebs that snare the dew until they are starfields. She spoke to him of the myriad colours that exist in dreams but nowhere else, not even in the wings of Syor. She spoke to him of how every single raindrop contains within it everything of the World there ever has been or ever could be. She spoke to him of the whispers that are gentle rain and the sighs that are mist clinging to the

low hills. She spoke to him of the fire in an insect's wings and of the life that warms amber. She spoke to him of the way two may become as one, so that the fires of their breath become but a single fire, and the pulses of their being become but a single pulse.

And as she spoke the two of them drowsed together in that high eyrie, but still she spoke on though both slept, her voice the meagre sound of soft flesh stroked against dry moss.

Night came, and in its pursuit the dawn, and as the sky's eye opened so did those of Barra 'ap Rteniadoli Me'gli'minter Rehan. He felt the small warmth nestled to his shoulder of Angrboda, who still slept on. And he felt also in his heart a great burgeoning of joy, for he knew that in the night the Disease-that-is-Despair had been vanquished from him, its sly armies driven from him. Then Angrboda

woke also, and felt through his great scales that the sickness was gone from him, and she piped her own joy.

'Great one,' she said, 'great Barra 'ap Rteniadoli Me'gli'minter Rehan, before whose outthrown wing and blazing eye even the storms cower, you have driven back the Disease-that-is-Despair as yet one further testament to the greatness that is yours. I bow myself before you, as will all others when they learn what you have done.'

But great Barra 'ap Rteniadoli Me'gli'minter Rehan threw back his wings and his head, and he breathed a fire that set the Moon to flames, and he roared in a voice that sought out every last crevice in the World so that its words might be heard there:

'No, it is not I who have brought defeat to the Disease-that-is-Despair, not I but one who has hitherto been tallied as the least among all, lesser than the lowmost Lesser. The Disease-that-is-Despair has been cast down not by my might but by your gentleness, by the gift of yourself that you have given me, for you are indeed, Angrboda, greater than any Greater, greater than I myself, who had become least of all there is through the lassitude that had seized my heart.'

Saying this, mighty Barra 'ap Rteniadoli Me'gli'minter Rehan took her gently in his mouth and flew with her down to where his nest and their roost-fellows waited silent, for they like all others had heard the words he had uttered from the high peak. And as he set her down he roared once more, again in a voice that sought out every last crevice in the World so that its words might be heard there:

'By what she has done, this dragon Angrboda, discarded by all as least of any, has shown herself greater than all. She is lesser than none, lesser not even than I myself. From this day I declare that no dragon shall be called Greater than any other through the judgement of their birth, but only through their deeds and the goodness of their hearts. And I declare that no dragon shall be called Lesser than any other through the judgement of their birth, but only if they show their hearts are pale. For not only has Angrboda driven the hordes from me of the Disease-that-is-Despair, she has taught me also an even larger thing – that two may become as one, so that the fires of their breath become but a single fire, and the pulses of their being become but a single pulse.'

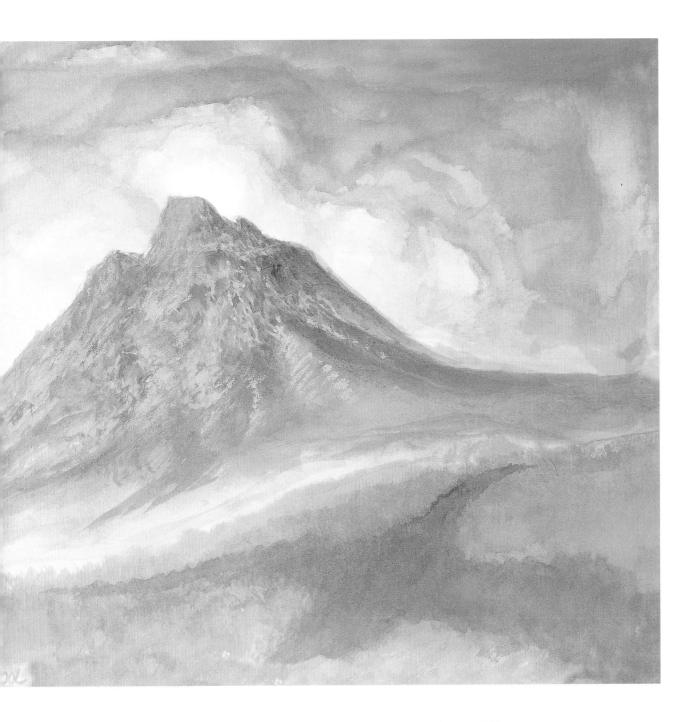

Barra 'ap Rteniadoli Me'gli'minter Rehan lived long beyond his
span, and wherever he went he told of Angrboda and what she had
taught him. For she herself lived not many years past this, succumbing
to the fragility of the body she had been given at her birth and that had
been further weakened by the starvation her roost-fellows had inflicted
upon her. But her voice can still he heard in the wave of grasses, and in
the sound our wings make as we fly through haze.

The high place where Angrboda brought her love into the World
is now called Starveling in her honour, and in that place many great
events have been played out, but none greater than this.

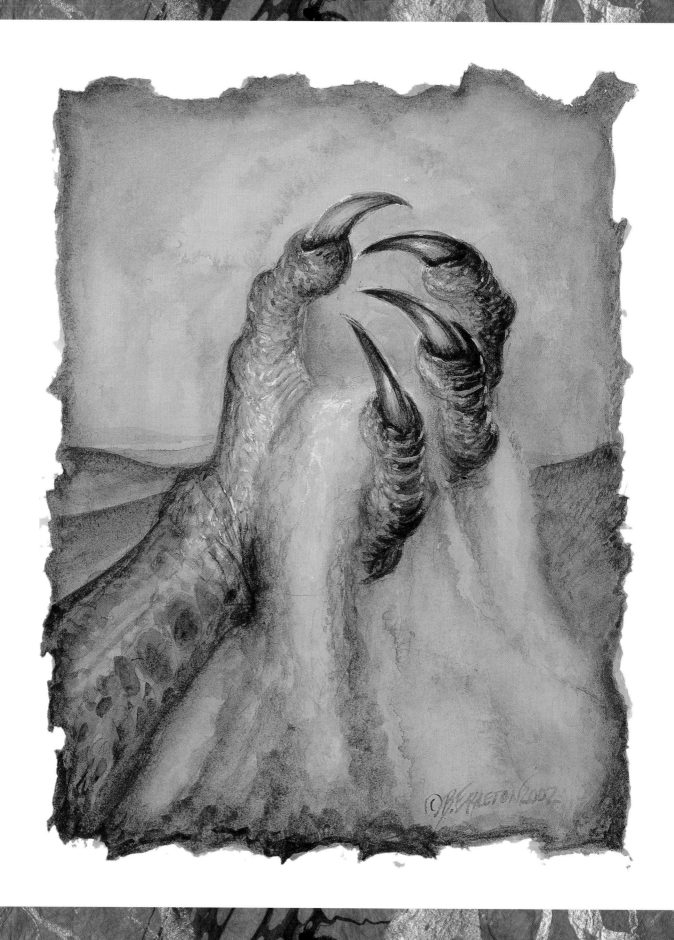

THE DRAGON UNDER THE SEA

IN THE ANCIENT TIMES, in the days when the World was still a newborn, with a newborn's fresh eyes, and when the folk of the World were giants, there was a dragon named Nadar who believed he could see things that were to come. He would dream the stars of the sky would fall, and soon indeed the night sky would be filled with the swiftly moving lights that are the Stars-That-Flare, that are the stars' deaths. Or he would dream of plague and death, and sure enough plague and death might soon fly on silent wings among the Great Ones. Or he would dream of tempests chewing at the shores of the islands the Great Ones had made, and within the year a mighty sea-tempest would spring up and feast upon the land.

These things would have happened anyway, and it took no dreams to know this would be so, but Nadar believed his dreams truly foretold them, and even brought them into being. And those around him began to believe this too, so many came to ask him what he foresaw, and were led into ways of falsehood.

One time of darkness he dreamed that the Moon would devour the Sun, and he dreamed this again one more time, and so he came to swear this was a true dream, and there were great lamentations among those who had lent him their souls – for what is belief but a lending of

souls? With the Sun devoured, the World would surely become a place of eternal dark and cold, watched only by the chilly distant stars and the ice-laden stare of the fattened Moon. This, they said as they huddled in their misery, was the worst foretelling there had ever been or ever could be.

And Nadar's vanity was swollen that he alone had dreamed this

thing. He thought, although he did not dare think it aloud, that he had been blessed and chosen, he alone, by the Memory of Qinmeartha to know of the ending time. His chest puffed crimson and his breath struck fire through the valleys, so eminent was his vanity.

Even greater did that vanity grow, until he came to consider – and this his folly, which matched his vanity, led him to talk of to others –

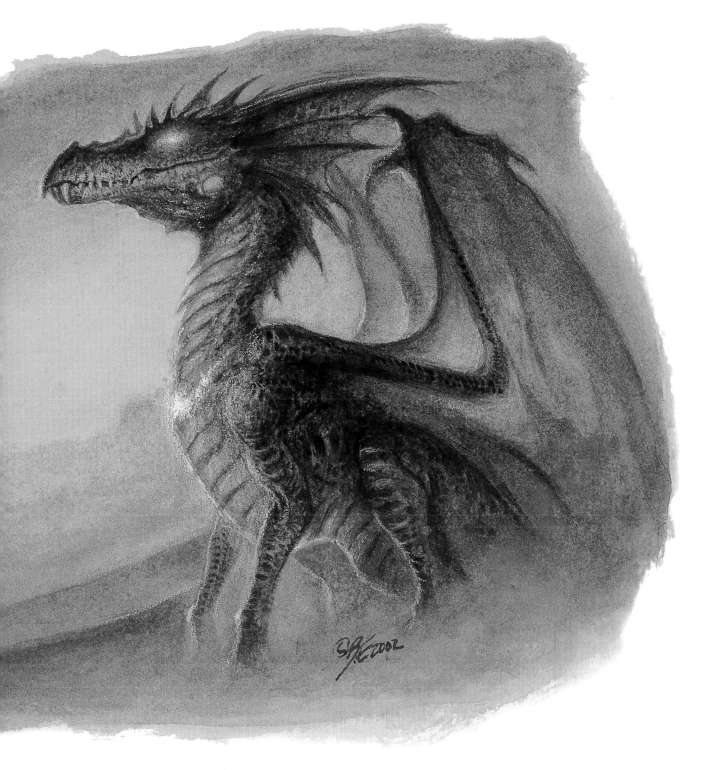

that he, he alone, was being blessed and chosen by the
Memory of Qinmeartha to stop this thing, this gorging of
the Moon upon the life-fire of the Sun. So much, as we have
said, he told to those who had lent him their souls, and more
he told them: that he would go on his own into the Great
Desert Where There Are No Shadows and, once there,
capture the Moon in a net of sand so that the Sun could be
left safe from its appetite.

And so Nadar went into the Great Desert Where There
Are No Shadows, taking with him things vital to the holding
of life: food, water, and a necklet of the broken stones that
shine because of the memories trapped in them. There, in
the desert, he heard the music of the sere lands, although
all he thought he heard was the howl of the wind across the
hills of sand. There he saw the sand creatures rise up to
dance to that music their dance with each other, although
all he thought he saw was the sand kicked up in eddies by
the gusts. There he smelled the drying blood of the time
before time began, although all he thought he smelled was
the dust of the desert.

In the darkness of that night he stared up at the
splinter of the setting Moon and the needles of the stars

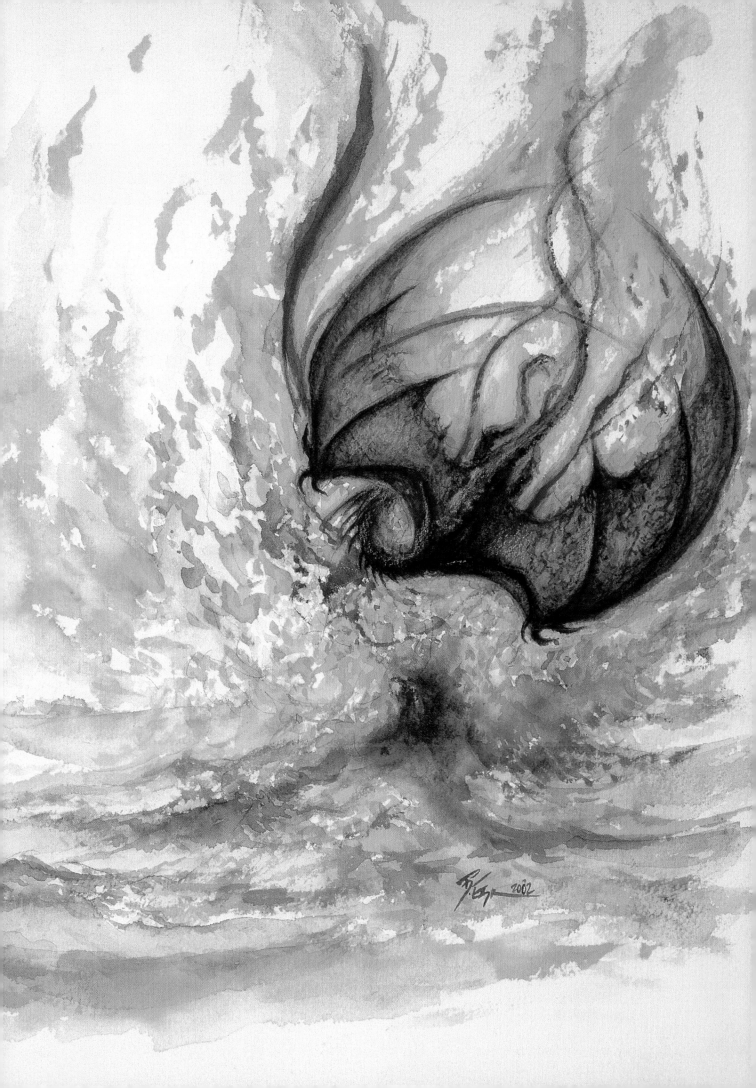

and imagined he saw woven there-from the Memory of Qinmeartha, unmindful that the Memory of Qinmeartha could not be seen and can never be seen by any dragon alive nor even dead. And he called out to the Memory of Qinmeartha, or so he thought, in the voice of one who has the unbending foolishness to imagine himself a ruler over others.

'Heed me, mists of the great deeps, echoes of the four breaths that became the Dream of Qinmeartha, memories of the dawn that together cling to form the Memory of Qinmeartha.'

When the sky did not answer he thought that this was because it quailed in silence before his awesome majesty.

'Heed me and obey me, soft Memory of Qinmeartha, for have you not signed to me through the dreams you have given me that you desire to be my servant?'

And still the sky said nothing, which Nadar believed was a show that it cringed servile before him.

'I command you to add your essence to my claws so that I may knit from these grains of sand a net with which to snare the Moon.'

The mindless mind that is the Memory of Qinmeartha has laughter plaited into its invisibility, and so, when it saw this impertinent nestling strut upon the desert or flutter importantly above it, it determined to let matters take their natural path.

So Nadar crouched for all the long hours until the dawn came in the sands of the Great Desert Where There Are No Shadows and strove with his forefeet to knit grains of sand together. But all the grains of sand would do was cascade from his claws to melt back among their brethren. And with the coming of the dawn he knew, or so he thought, that the Memory of Qinmeartha lacked the power to guide his claws, and that a net could never be knitted from sand if it had not been knitted that night.

All that day long he slept as the Sun baked the air into

half-glimpsed eyries among which the small creatures of the desert scampered like leaderless armies.

When the night came, Nadar woke again with his resolve strengthened. The Moon that he saw setting in the west was now not even a splinter but instead the gleam an eye makes in the bitter midnight.

And again did Nadar address the skies.

'Heed me and obey me, timid Memory of Qinmeartha. I command you to add your essence to my claws so that I may knit from the feathers of the clouds a net with which to snare the Moon.'

The mindless mind that is the Memory of Qinmeartha has impatience plaited into its invisibility, and so it determined once more to let matters take their natural path.

Nadar flew up into the darkness and sought one of the rare, gossamer clouds that are to be found over the Great Desert Where There Are No Shadows. Although it fled from him in the high cold air, he caught it easily enough and pulled it to him. But as he attempted to intertwine its strands they melted and drifted away from him among the fields of stars, so that he was left weaving the empty air.

At last, as the dawn broke, he sank back to the floor of the Great Desert Where There Are No Shadows. This time there was no temptation to sleep, even though exhaustion trudged heavily laden through his bones – for what was spreading across the horizon but the tranquil green and grey smears of what Nadar believed would, without his intervention, be the final sunrise of the World?

By now he had a fury in him that made his head bulge close to bursting and his fiery breath spit like molten globes. He had attempted to knit the grains of sand, but they had glissaded from his strengthy claws. He had attempted to knit the fibres of a cloud, but they had melted from him. Out here in the Great Desert Where There Are No Shadows there was nothing more from which he might weave a net to snare the Moon, only the mockery of the heat, but that, even Nadar knew in his wrath, can never be captured.

And then, as the Sun rose towards its encounter with the hungered Moon, he saw that the Great Desert had been ill-named, for growing in front of him like a pool of squid ink was the shadow of himself. Here was something, one last thing, that he might hope to braid.

'Heed me and obey me, foul Memory of Qinmeartha,' he bellowed

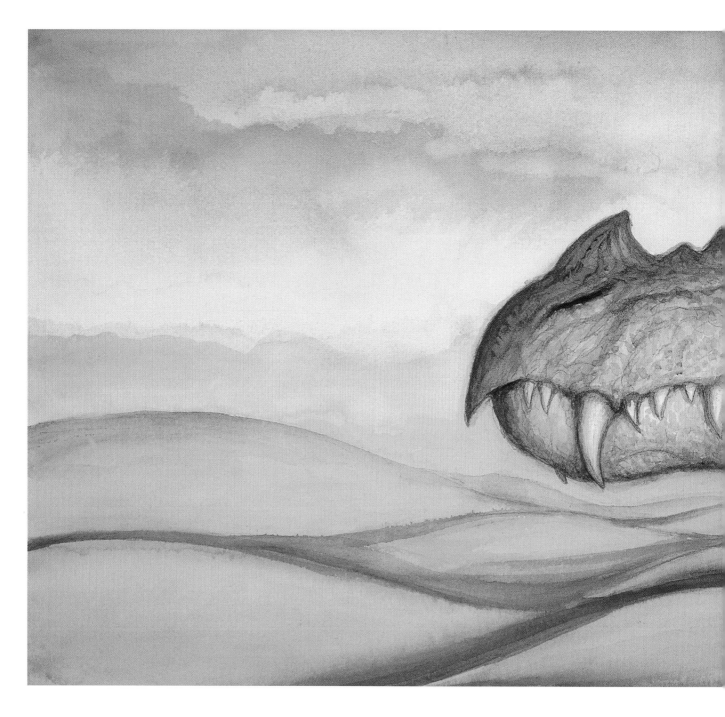

at the ochring heavens. 'Heed me or bear the burden of my curses. I command you upon the pain of your dissolution to add your essence to my claws so that I may knit from my own shadow a net with which to snare the Moon.'

Now, the mindless mind that is the Memory of Qinmeartha has anger plaited into its invisibility, and so in its fury, that was as white as lightning, it determined this time not to let matters take their natural path.

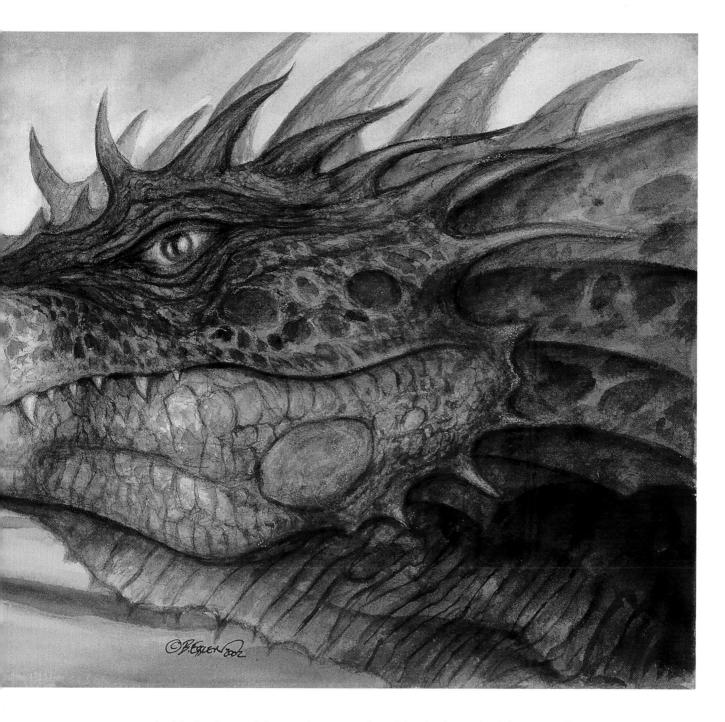

As Nadar leaned forward to snatch at his shadow, the Memory of Qinmeartha let the shadow coalesce to almost-substance, so that the insolent dragon could feel it against the taut flesh between his questing claws. He brought the shadow to his chest, where it moiled coldly against his softer scales, its form ever sullenly billowing as if it were a tiny thunderhead. Picking at it deftly with the sharpmost points of his quicksilver claws, gathering himself around it to shield it from the pryings of the desert wind, he made of it a floss of darkness that he

then skeined across the hooks of his wings. From the fine cords so formed he knotted and knitted a net that was lighter than any shadow there ever had been or ever could be.

And once his shadow net was done he looked up imperiously towards the zenith, where the Moon grew so close to the Sun that already he could imagine its jaws were open wide. But Nadar hardly saw this, for instead he was looking beyond them both to where he thought the Memory of Qinmeartha cowered for fear of him.

'Heed me and obey me, craven Memory of Qinmeartha,' he cried with a voice that might have awakened icefields. 'Heed me or be banished by my might beyond the reach of remembrances. I command you upon the power that lies at my kernel to add your essence to my claws so that I may cast forth this net of my shadow and snare to me the Moon.'

The Memory of Qinmeartha made no reply. The skies stilled in terror of its rage, but Nadar thought they stilled for him.

And so he cast his net towards where the Moon spread its arms to

seize the Sun. Yet the net did not fly from him. Rather did it wrap some of its filaments around the bladed claws that had created it, tugging Nadar himself in the direction of his hurl, so that, struggle as he might, he rose unremittingly above the Great Desert Where There Are No Shadows, whose sanddrifts and valleys wrought themselves into a mocking cry of mirth as he ascended from them.

High above the pitilessly cawing sands did Nadar rise, drawn by the net that he himself had made, until he was in seconds halfway between the World and the Moon, where loneliness is as solid as stone.

Then were his ears beaten by the voice of the Memory of Qinmeartha, which was loud enough to fill all the endless spaces there ever have been or ever could be.

'Cursed child of vanity, fool of the grand, know now your smallness, know how dimly your light glows even against that of your shadow. Greatness is something you must earn through toil and through the shunning of greatness, not something you can seize, even if those around you are likewise for a time deceived by your illusion. The child

111

of arrogance is debasement, is the execration of eternity. Greatness is something you can see only once you have stared into your own lowlihood and recognized how close you are to the coarse earth from which you sprang, how little you matter to the Dream of Qinmeartha.'

'I command you to cease this,' said Nadar, but his voice was the brief hiss of a twig consumed by flames.

'You can command nothing, for you hold only false greatness inside you,' said the Memory of Qinmeartha so loudly that there existed nothing but its words.

Then Nadar knew that death attended him close by – not just death, but the shrouding over that is beyond death, so that the soul becomes as if it never has been.

But the mindless mind that is the Memory of Qinmeartha has mercy plaited into its invisibility, and it held back from punishing Nadar with the punishment that his vanity had earnt him. Instead it let itself fall into silence, its voice receding into the echoes of the four breaths that became the Dream of Qinmeartha.

The Moon devoured the Sun, but from the Moon was birthed a new Sun whose eye was clearer even than before.

And the Memory of Qinmeartha took the dragon Nadar, who had presumed to require the allness to bow to his bidding, and it threw him, still entangled in the net of arrogance that he had knitted from his own shadow, to the bottom of the ocean, the last curse that it laid upon him being that he should never die, but live there always.

Sometimes today we dragons forget too much our lowlihood and think ourselves greater than all that is around us, and when too many of us become this way the Memory of Qinmeartha lets the Moon feast upon the Sun once more, to sign us that our vanity is the vanity of the lake that believes the images of the skies it mirrors are brighter than the skies themselves. Yet, each time, the mercy plaited into the Memory of Qinmeartha allows the newborn Sun to creep again from the maw of the Moon so it may watch ever more clearly the stories that unfold across the face of the World.

And Nadar lives on forever in the deepmost ocean, where he breathes but twice a day, the slow pulsing of his vast flanks making the waters ebb and flow across the shore.

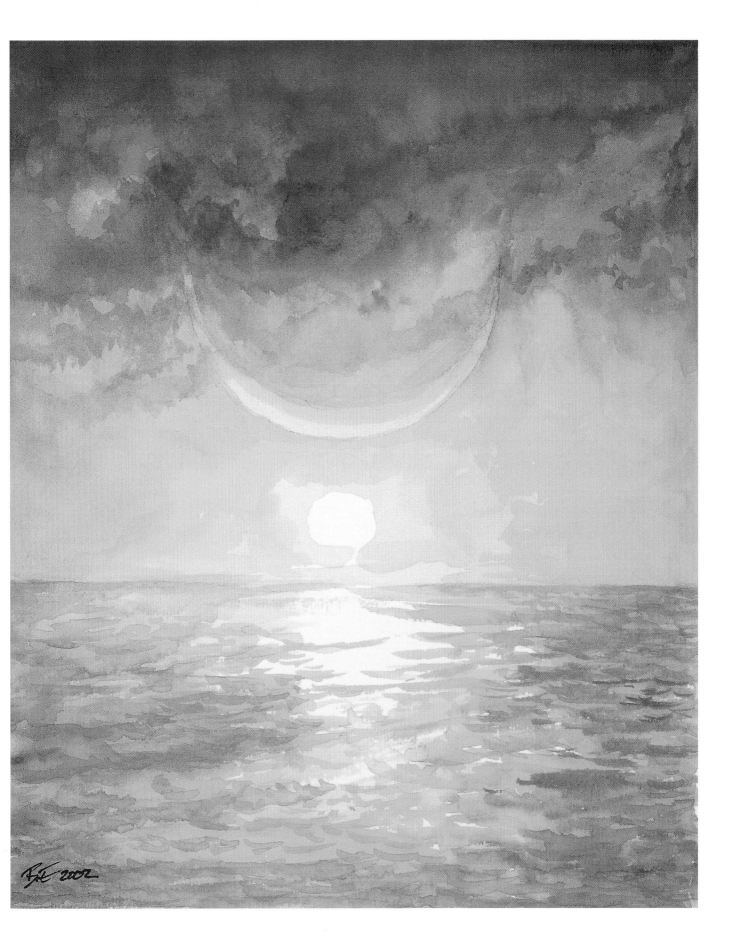

DRAGONHENGE

AND IT WILL COME TO BE KNOWN to all in the World that the glory days of the dragons are soon to be done.

Those final times will see the return to this World of Anya, she who mated with the Living Light of the North, she who saved us from the vile malice of the ice dragons. She will be born as any other chick from an egg undistinguished from any other egg, but the fire in her eyes will mark her for who she is. Yet she will shun admiration, even as her growing bravery is woven into the cloth that is ourselves. When her body reaches its maturity, she will have wings that span the stars, her voice will be a roar that deafens mountains, and the blaze of her breath will make the Sun dim. Her claws will be the Stars-That-Grow-Crests. She will have within her the great Memory of Qinmeartha and the stuff of the Girl-Child LoChi. She will be the completion of our people.

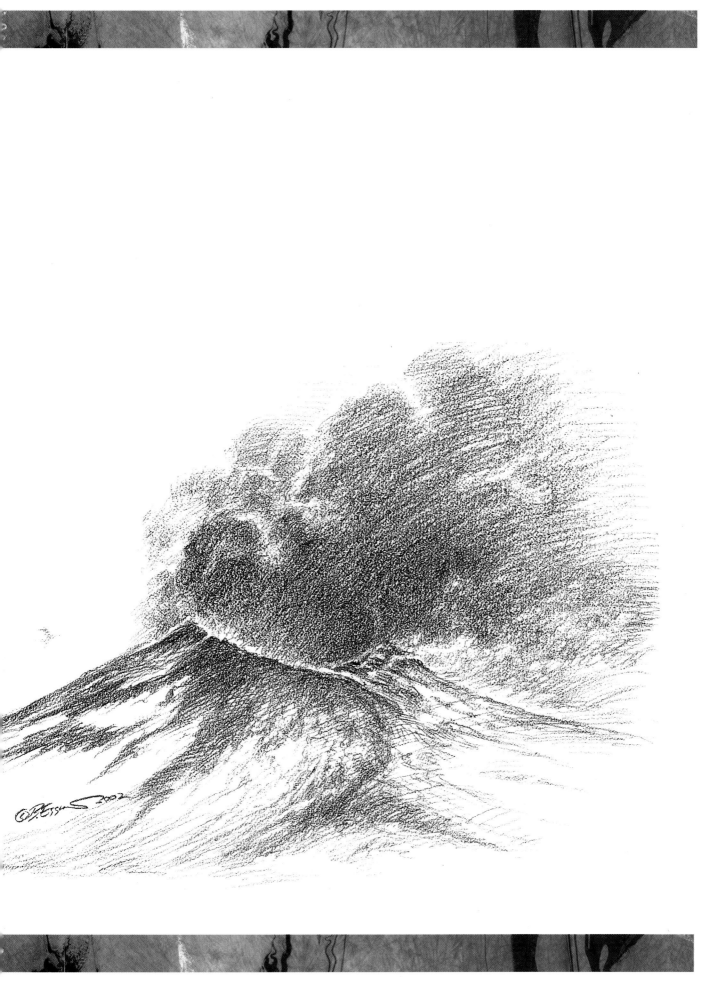

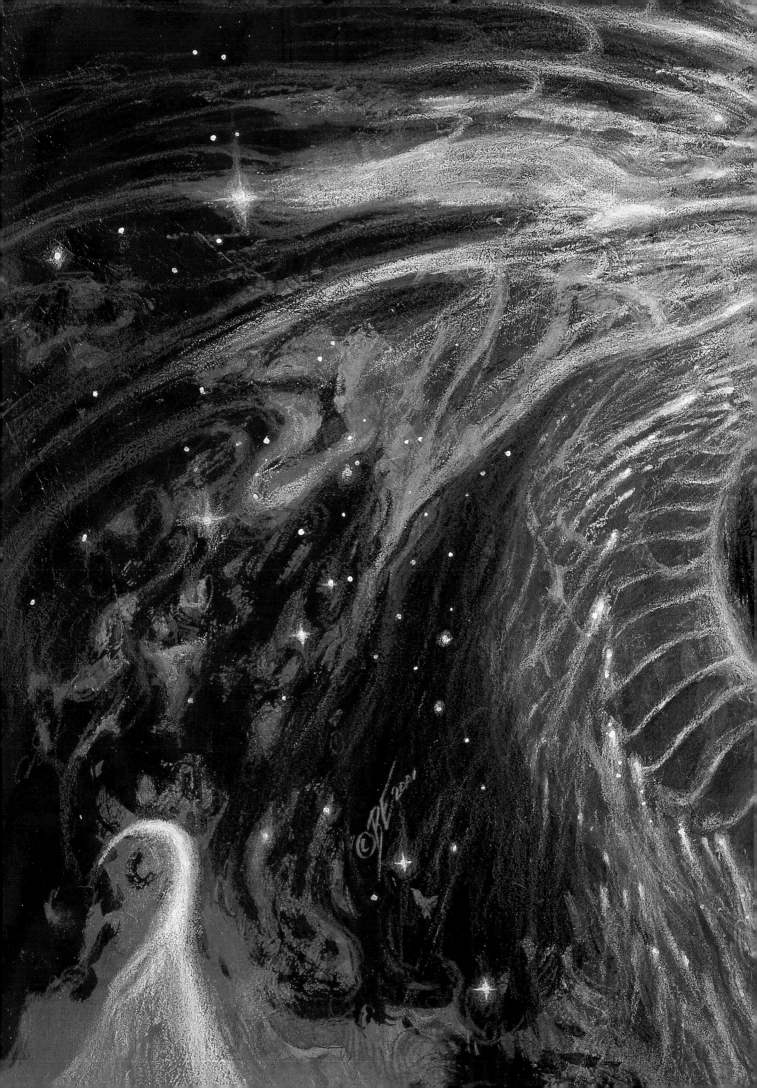

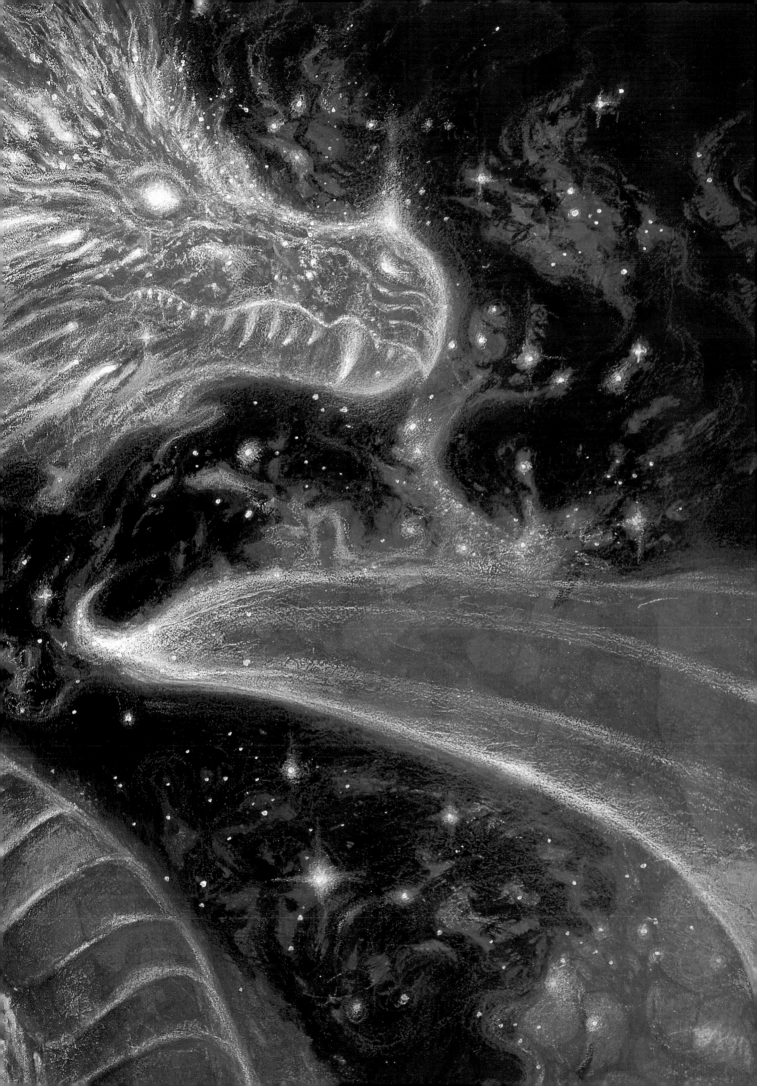

She will be brought back to the world because of the rebirth of the ice dragons, spawned as they shall freshly be from eggs that have lain forever unseen and unsought beneath the snows of the cold places. She it will be who must battle them, in the final war.

She will win that war, as she did against Garndon when time was young, but so much will we be weakened by it, with so many of us lying slaughtered on the mountainsides, that the days until our passing will become tallied by talons. Even the Mountains-That-Roar will become mute, in reverence for the forthcoming hour of our demise.

And then will the Memory of Qinmeartha speak up within her, making its voice heard.

'You shall not forever die,' it will say. 'Though your bodies will perish and the flesh and bones will melt back into the Rock-That-Flows from which you came, yet you will live on in the minds of the humble creatures of the World until time itself will cease.'

Then will the Girl-Child LoChi speak up within her, making her voice heard.

'I brought music and laughter to the World,' the Girl-Child LoChi will say. 'These too will die as the dragons die, but they will not be forever lost, for they will live on in the minds of the humble creatures of the World until time itself will cease.'

Finally will Anya herself speak up within her, making her voice heard.

'I have been a fleshly being more times than once,' Anya will say, 'and so I know the frailty of recollections even among we dragons. How much more fickle will the memories be of the humble creatures of the World, when they inherit the land? We must leave a sign for them, a sign that will persist until the stars flicker their last, a sign that will preserve in their minds for eternity the memory of all that we have done, of how we have taken the World and moulded it, of how we have brought the Dream of Qinmeartha to its final fruition, as a tree will bear fruit to drop to nurture the forest beasts.'

So Anya will gather about herself seven others of those who remain hale from her own nest. Together they will fly the winds of the World, seeking each a Mountain-That-Roars, eight in all, that has yet to cease its blazing voice.

And they will find the last eight Mountains-That-Roar still to be lighting the skies with their life.

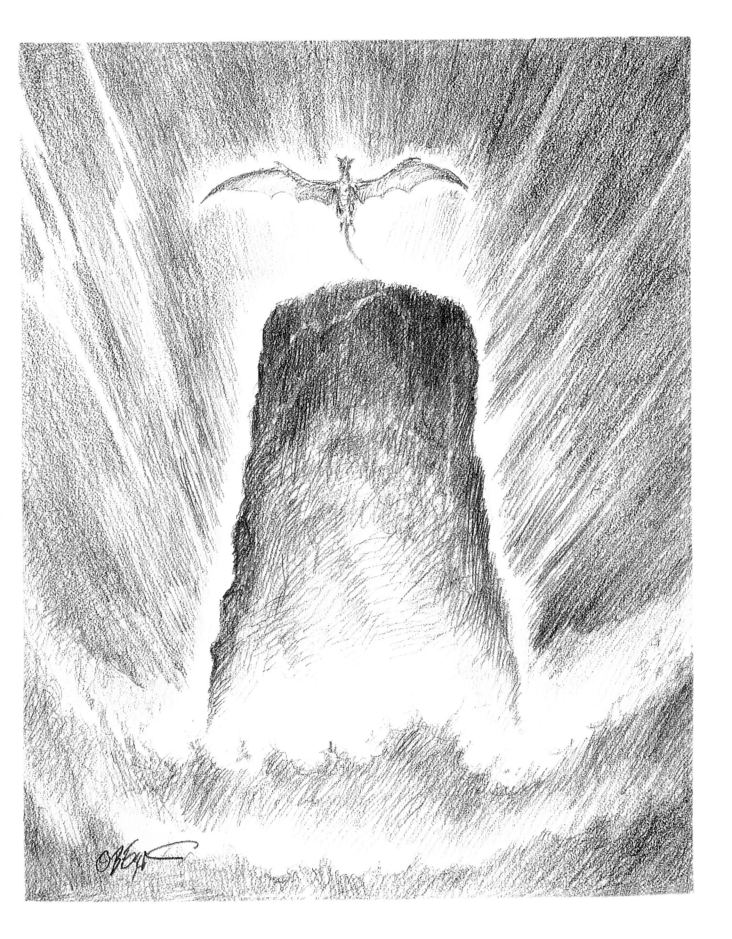

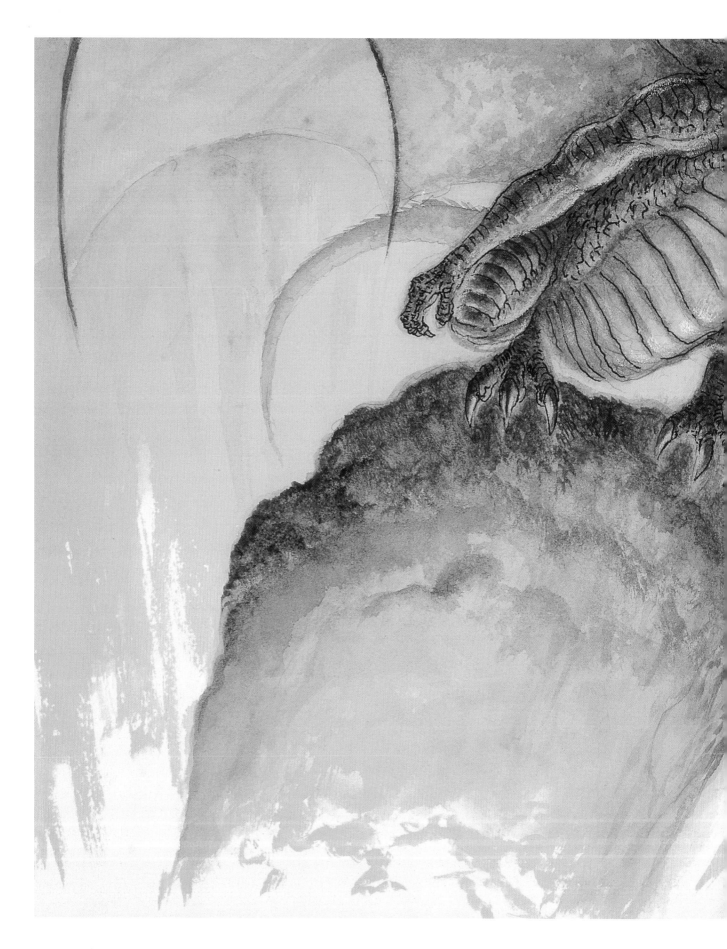

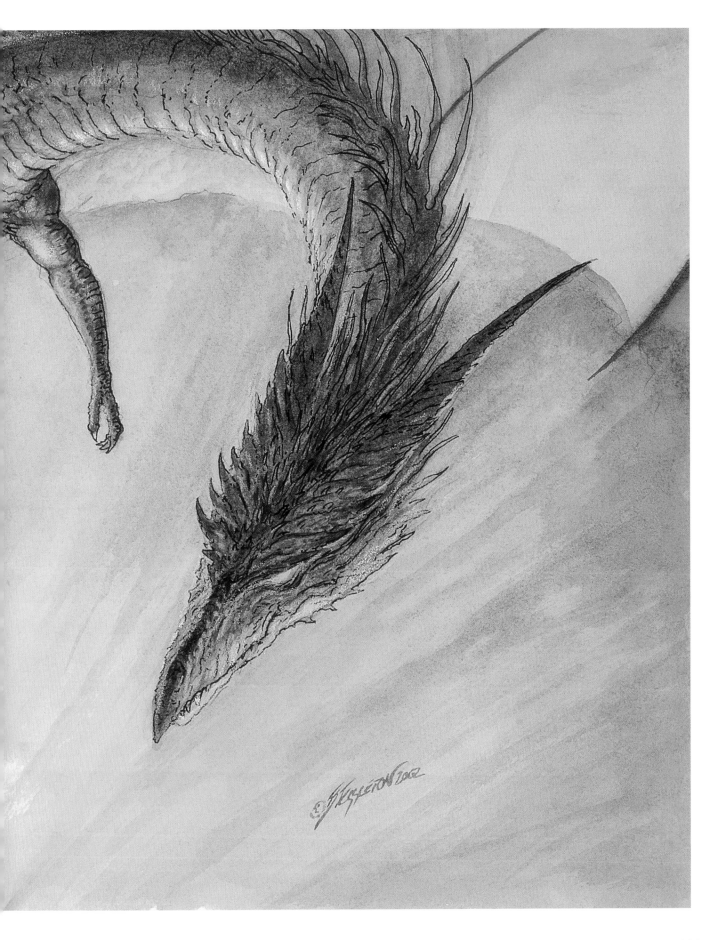

Then will each of these strong dragons descend right into the throat of a Mountain-That-Roars, where the fires are so white that even tough dragon scales wither to the flames, and they will each grip claws that become stark pain into the tongue of the Mountain-That-Roars, drawing it up with their wings beating hurricanes that flog all the World. And so will the very last of the Mountains-That-Roar fall silent, perhaps forevermore.

Far aloft will the dragons fly, the mountains' tongues still afire, so that they become as eight suns lighting the World beneath. And then will each of them plunge into the ocean, so that its waters are set boiling all around the World from the heat of the tongues. And they will hold the tongues there until they are almost cool, which will be when that next night comes. At last, for the tongues will still not have given up all of their heat, the eight dragons will bear them on high once more, to bathe them in the waters of starlight, colder by far than those of the ocean.

Now the tongues will be more than tongues, for they will be also in part the dragons that have clutched them in seared claws under the boiling waves.

And at the last the seven great dragons will fly to where Anya has been awaiting them, holding in the high air the tongue which she herself has plucked from the throat of the greatest of all the Mountains-That-Roar and quenched in the seas and starshine. Where she will be there will be also an island, born from the seas that very moment, an island that will be called Albion and will be forever shrouded in the mists born of her mind, and of the mind of the Memory of Qinmeartha, and of the mind of the Girl-Child LoChi.

Upon this island will the eight saviour dragons set the tongues in a ring, the tongues that are now more than tongues but also dragon souls. There they will stand until time greys and fades like smoke, shielded from all that seek them unworthily by the mists born of those three minds. They will be forevermore what we are, as we will be forevermore them.

Then will the seven saviour dragons fly each to a far and high eyrie, where they will fold their scorched wings for one last time, and lay their raw heads upon rocks, and let their souls journey to join the stars.

Only Anya herself will remain, upon the island shielded by the mists, bearing within her the great Memory of Qinmeartha and the

stuff of the Girl-Child LoChi, for thus she will be the completion of our people even as her flesh departs and her bones become ash. She will be there, though eyes can see her not and neither a talon touch. But any who come there will breathe her soul into their own.

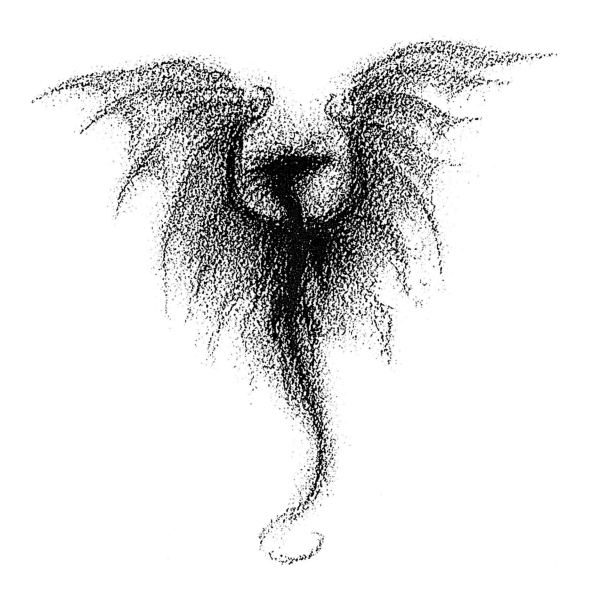

These are my memories not of the times long gone, but of the times that are yet to come.

ACKNOWLEDGEMENTS

My heartfelt thanks go to Marianne Plumridge for making life (and
deadlines) easier when things got tough; to John for his poetic text
(I only hope my images match his words); to Shinichi Wakasa for being
the World's Best Creature Maker (Godzilla, for one) for the constant
inspirations; to Malcolm Couch for his superb design; and to Cameron
Brown and Colin Ziegler for thinking this was a good idea from the start.
To those who liked what they saw in this new direction in my art, my
thanks; to those who didn't, too bad.

Bob Eggleton

Bob and I benefited enormously from suggestions and ideas offered
freely by Pam Scoville and Marianne Plumridge; to them our considerable
thanks. Thanks also to Emma Baxter, Cameron Brown and Colin Ziegler,
who kept the faith. Huge thanks to our designer, Malcolm Couch, who
has been in on this project since it was hardly more than twin gleams in
our eyes, and whose constant enthusiasm has been invaluable to the
whole enterprise. My thanks to Bob, for giving my visions such gorgeous
flesh, need hardly be stated. And the biggest thanks of all to Pam for, in
particular, putting up with me while *Dragonhenge*
fought free of the eggshell.

John Grant